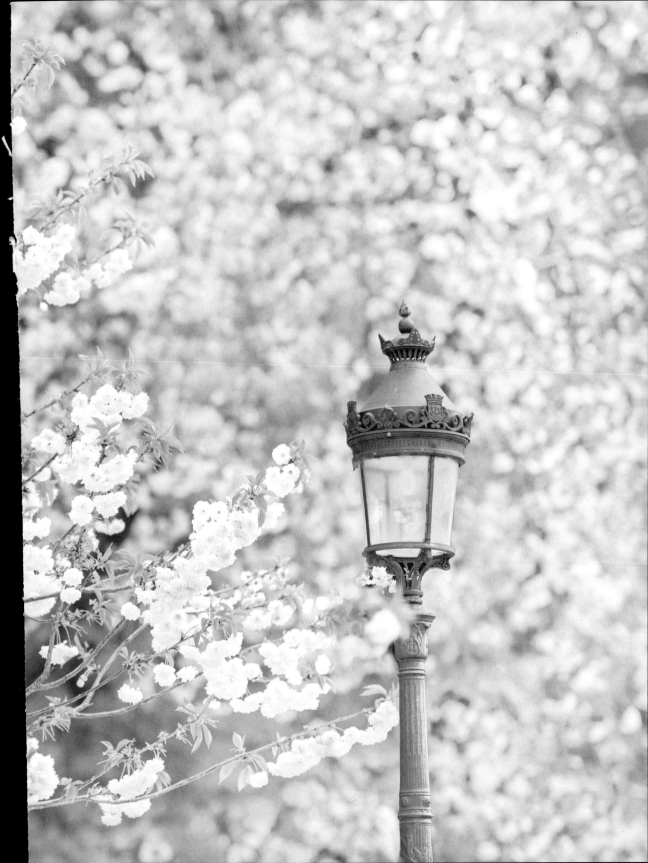

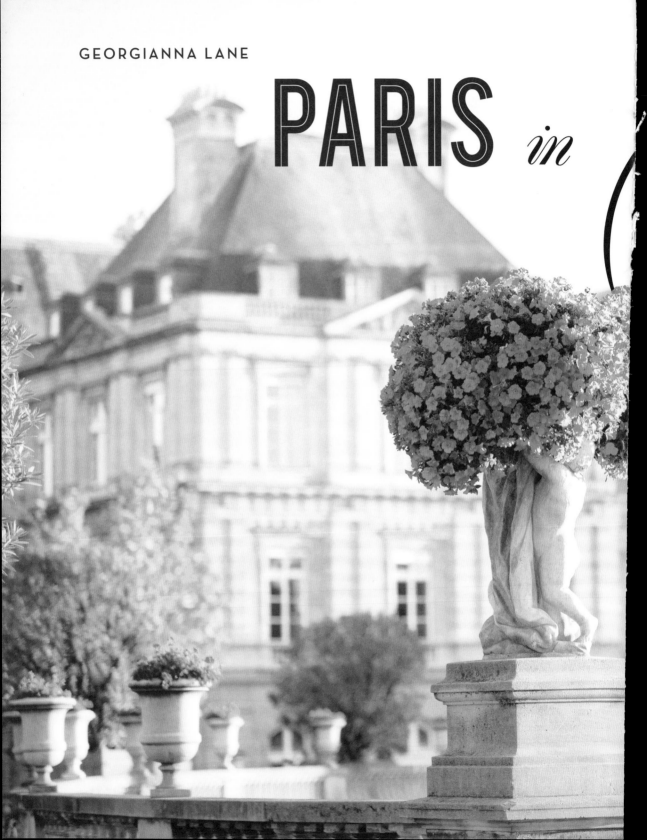

GEORGIANNA LANE

PARIS *in*

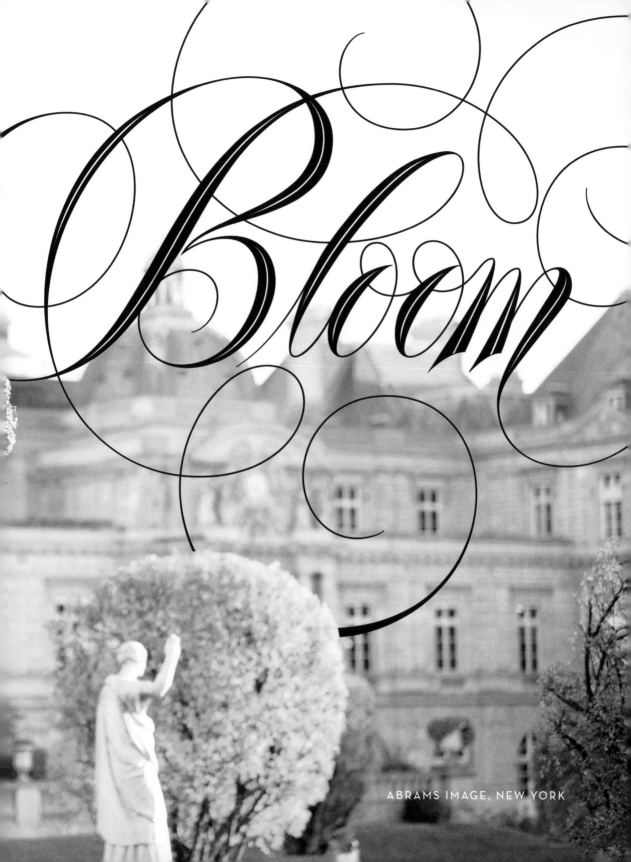

Bloom

ABRAMS IMAGE, NEW YORK

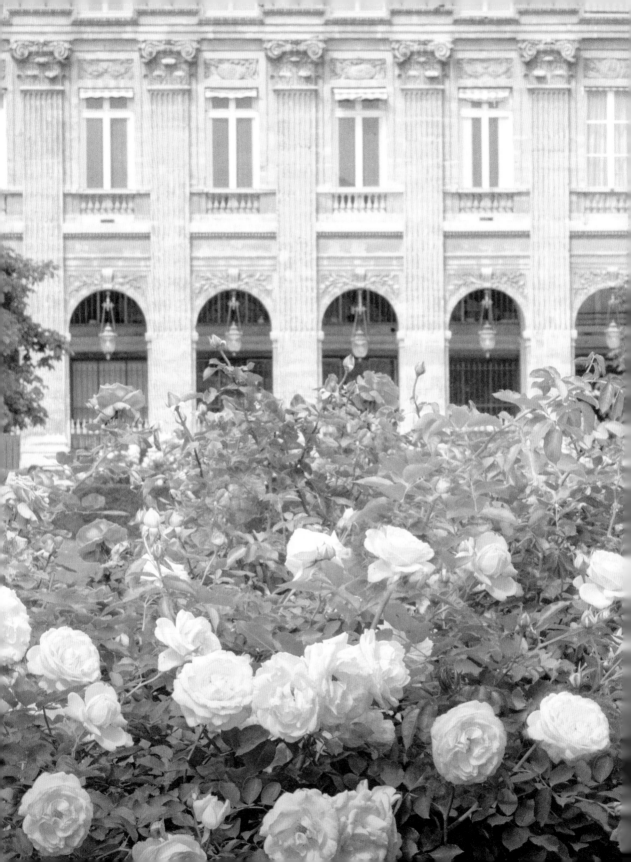

CONTENTS

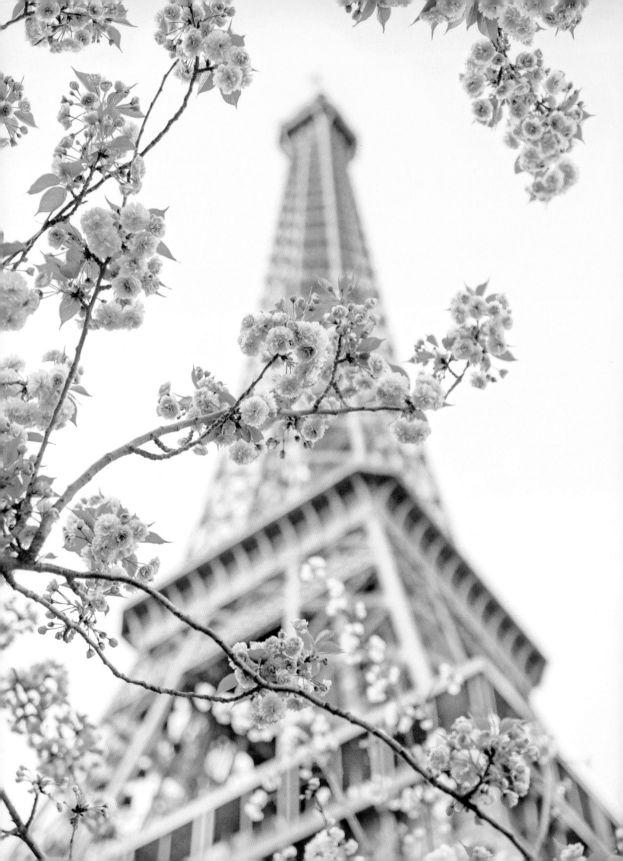

INTRODUCTION

PARIS—CITY OF LOVE, CITY OF LIGHT, AND CITY OF FLOWERS

My first and most indelible memory of Paris is in a flower-filled garden: my mother and my fourteen-year-old self share a picnic on the immaculately manicured grounds of Notre-Dame on the Île de la Cité—a simple but quintessentially French meal of cheese, pâté, plump raspberries, warm baguette, and a bottle of rosé, all purchased on the way to the island from our hotel on rue des Saints-Pères. The scents and sounds and sights are crisp and unforgettable—bright dahlias, geraniums, and roses line the faultless flower beds; one of the Bateaux Mouches floats by carrying laughing tourists; the late-summer sun warms the prickly grass; the magnificent rose window overlooks the scene as it has for seven hundred years. And, as we spread out our classic repast, the echoing bells of the cathedral chime the hour, putting an audible exclamation point on a perfect moment in time.

Though it would be many years before my return to Paris, the profound effects of that introductory visit remained. At that time, we were fortunate to view the renowned Impressionist painting collections in the intimate setting of the Galerie nationale du Jeu de Paume, an inspirational experience that had a powerful and lasting influence on my own creative journey and photographic style. Returning as a specialist flower photographer, I initially gravitated toward the plentiful gardens, flower markets, and floral boutiques. Always, I was struck by the artistry of Parisian presentation, whether a sumptuous planting in the Jardin des Tuileries or a gorgeous bundle of market roses, carefully bound in pretty paper and tied with ribbon, just so.

On subsequent trips, as my intimacy with the city deepened, I became increasingly captivated by the profusion of flowery embellishments that abound in the architecture and structures. Being very familiar with the form and anatomy of flowers, I felt great delight in discovering these same botanical motifs among the sculptures, door knobs and knockers, iron railings, majestic gates, stained glass, ceiling medallions, and myriad other decorative details. Curlicues, swashes, flourishes, scrolls—a rose-shaped railing here, an oriel window there. I'd found my own story of Paris, written out in visual verses of petals and leaves.

Documenting this physical poetry became a passion, and I returned again and again in all seasons. My image collections grew and expanded to include floral-themed embroidered ribbons, gilded books, beaded handbags, metal window traceries, wood carvings, frescos, paintings, silk fabrics, and garments. Visually pairing real flowers with their crafted counterparts was a natural progression that began nearly five years ago and continues to be a source of pleasure and challenge.

Throughout, Paris and I have shared many an early, dew-covered morning as I sought out a particular flower in a sweeping garden or happened upon an ornate door down a quiet street. This has proven a joyful alliance, a slightly conspiratorial adventure of discovering and revealing her bountiful beauties, unfolding in layers like the velvet petals of a cabbage rose.

And every day, on every walk, this flaneuse feels privileged and humbled to photograph such a visually stunning location. No matter how frequent or extensive my visits, I am ever in awe of the dreamers, architects, artists, and craftsmen who envisioned and created this magnificent city, one exquisite façade and one poetically rendered iron balcony at a time.

Thus, this book is my love letter to the French capital, an unapologetically romantic celebration of her abundant floral charms. My hope is that it brings them to life for you and sets you dreaming of your first, or next, visit to Paris, for she awaits to welcome you with rosy garlands and ribbon-wrapped bouquets.

Georgianna Lane
Paris, April 2016

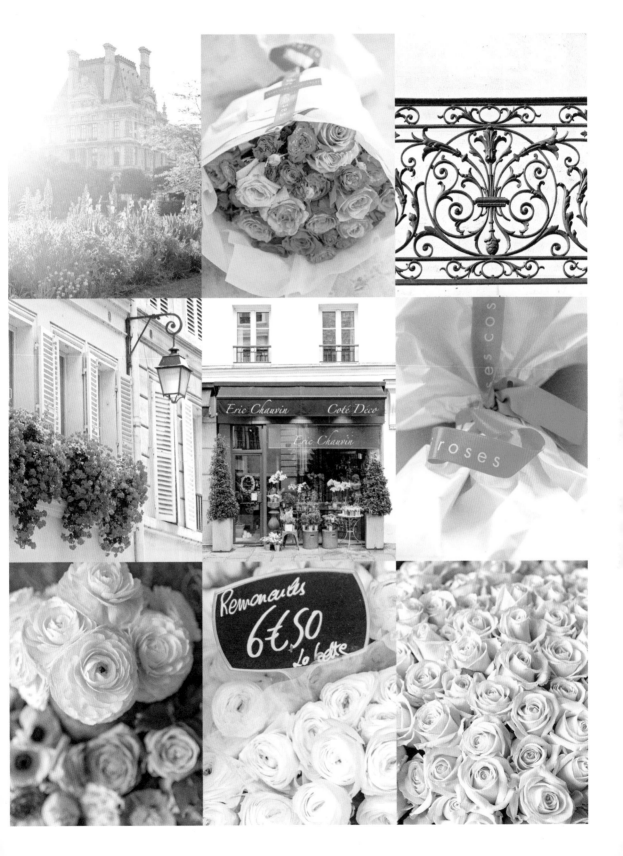

and

GARDENS

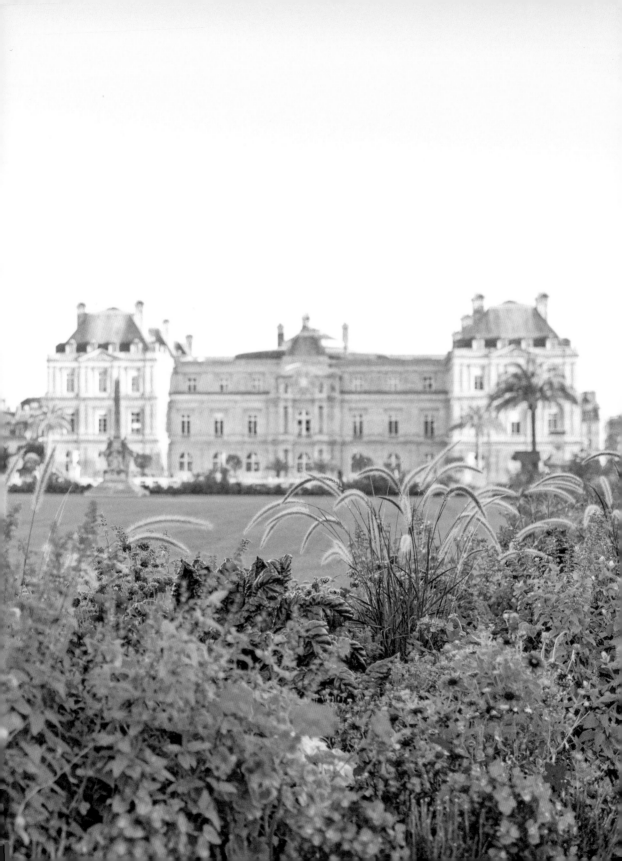

Some memories never fade: a stolen kiss, an exhilarating roller coaster ride, one's first trip to Paris. This most-stimulating city enthralls with endless diversions and delights, and residents as well as visitors all have their much-loved pastimes, their regular haunts, and their secret locales. Some *habitués* enjoy making a grand entrance upon arrival—a fanfare of coffee dates, fashion shows, wine tastings, and shopping expeditions. Others appear unannounced, slipping in quietly to observe and revel in the joy of simply being there. For many, the first stop is often outdoors in a park or garden.

The breathtaking open spaces are a wonderful way to introduce yourself to the city—and for the city to endear herself to you. For it is in those broad, elegant spaces that you can most feel the heartbeat of Paris and fall in with her rhythms: cautious optimism in spring, playful joy in summer, reflective calm in autumn and winter. Whatever your taste or style, Paris offers a garden to suit. In the 1st arrondissement, a favorite is the Palais-Royal, whose accessible scale and flamboyant plantings, counterpointed by soaring columns and arched colonnades, embody perfection of design. Across the river in the 6th arrondissement, the Jardin du Luxembourg provides a peaceful oasis of impressive proportions that never feels overwhelming.

These grand gardens possess an almost mystical quality, an alchemy of design and presentation that creates a calming sense of intimacy amid the sweeping vastness

of acres of trees and sculpture, ponds, and fountains. Perhaps it is the impeccable, soothing symmetry of the *allées* of plane trees or the clusters of welcoming chairs or even the quiet crunch of gravel underfoot, but to linger in a Parisian garden is to experience a palpable calmness, a slowing of the pulse and a desire to do nothing more than to sit back and take it all in.

And, throughout gardens great and *petits*, there are flowers.

An essential element of *la vie Parisienne*, flowers embody all that is romantic about the City of Love, and they are on passionate display in her public spaces.

In spring, bright tulips, cheery narcissi, and blooming cherry and magnolia trees paint the grounds with fluffy plumes of color. At the gracious Parc Monceau, the earliest blossoms can appear even at the end of January. In early April, one can visit the square Jean XXIII at the base of Notre-Dame and rest under a canopy of bursting cherry blossoms while marveling at the pink-tinged light playing over the pathway along the Seine and the children's sandbox beneath.

Come late spring and the first days of summer, another wave of floral abundance emerges: roses, peonies, delphiniums, lupines, and campanulas. At the splendid Musée Rodin, dedicated to French sculptor Auguste Rodin, *The Thinker* floats above lush beds of vibrant roses in late May, offering an unforgettable experience for the flower lover and art aficionado alike.

Venture outside the city to discover heavily fragrant mock orange and fields of daisies blooming, along with roses, peonies, and lilies, throughout the massive expanse of the gardens of Versailles.

Late August and September bring intensely hued cosmos, dahlias, and Japanese anemones to partner with the last of the roses. For a kaleidoscopic explosion of floral color, stop by the gardens of the Palais-Royal, where magenta, purple, and yellow petals dance on the early autumn breeze, sprinkled with spray from the beautiful fountains.

And, as winter approaches, a morning stroll in a Paris park can restore one's equanimity, bestowing a feeling of privacy and serenity in a peaceful, stable landscape

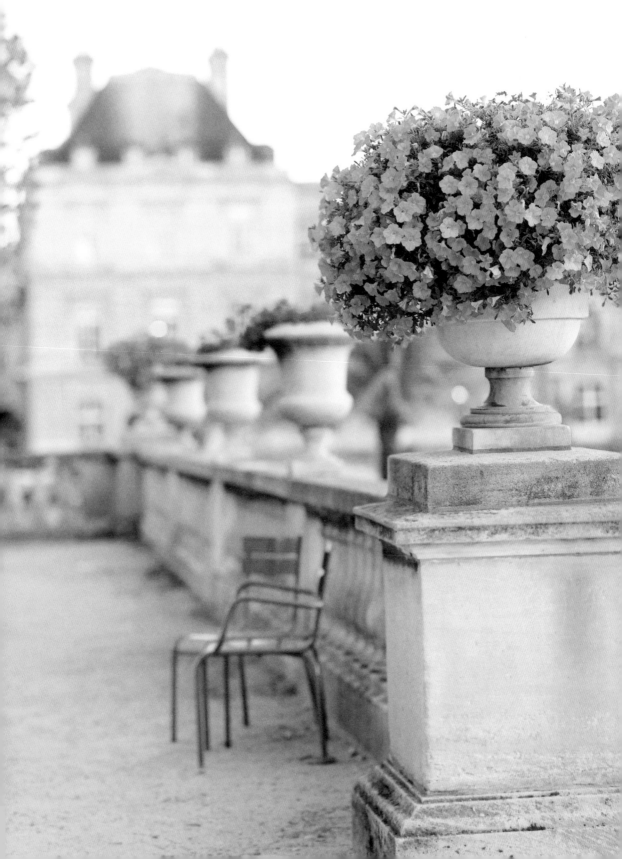

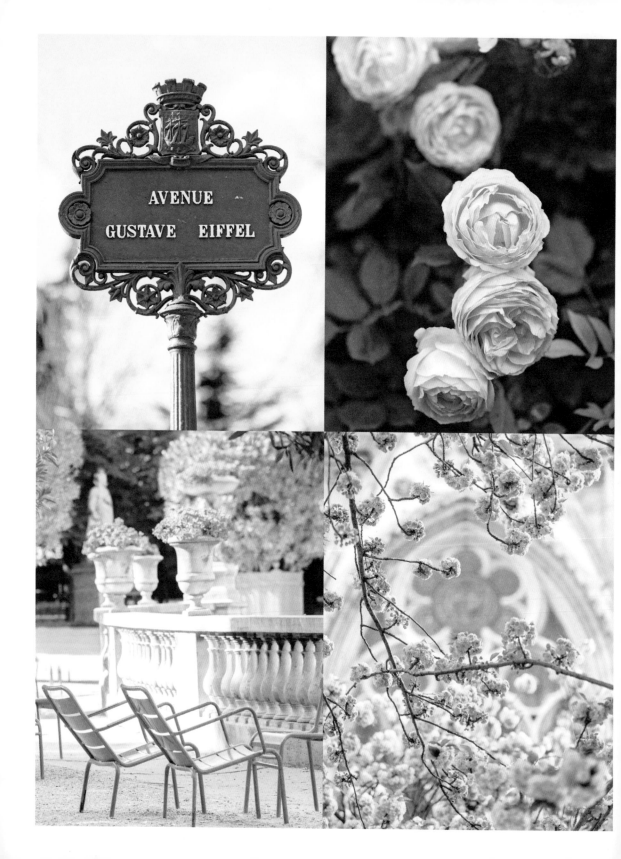

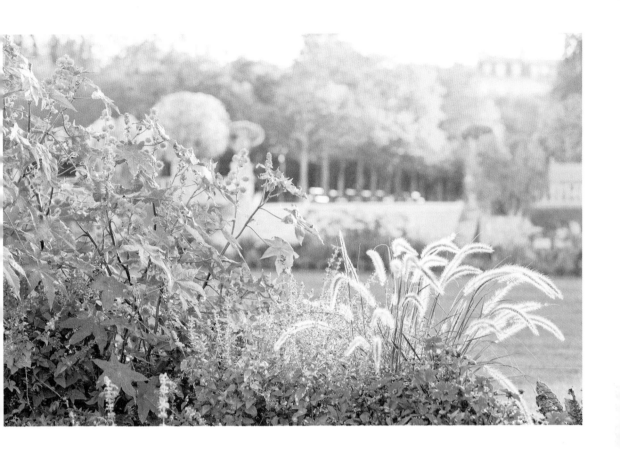

around which the chaotic, glorious energy of Paris swirls. Special mention must be made of the magical light that seems to be ever-present. At the Jardin du Luxembourg, the shimmering glow of the low sun illuminates the last of the leaves and petals, creating twinkling patterns of wistful beauty. Stunning vistas are at once humbling and invigorating, inspiring an expansive outlook of optimism. Little wonder that you'll find Parisians from all walks of life partaking of this wonderful elixir.

A Parisian garden is a blooming, visual poem. It is orderliness and refinement juxtaposed with exuberant plantings of ornamental flowers, punctuated by towering trees and sublime architecture. Within the rigid meter and strict rhythm of its pathways, gates, and precision layout, a floral sonnet flourishes and beguiles.

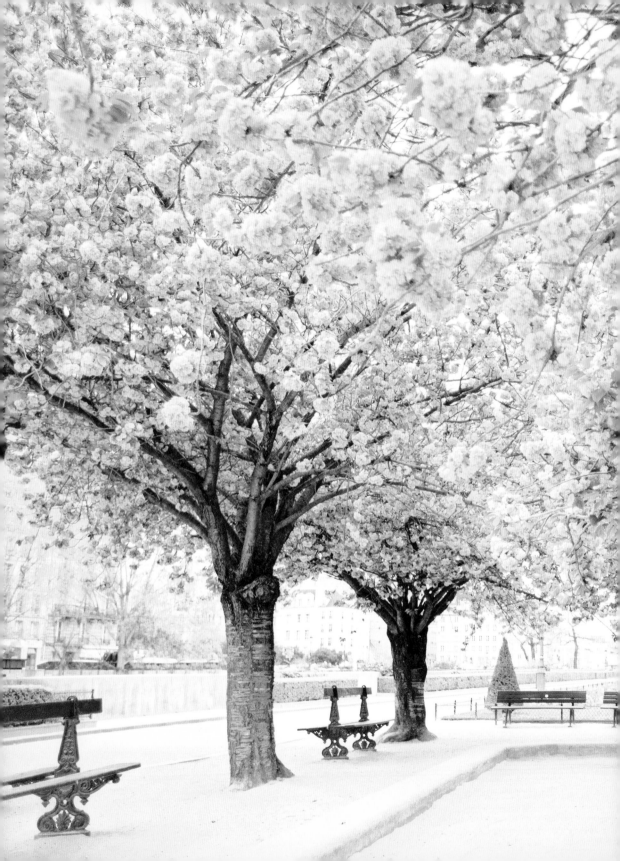

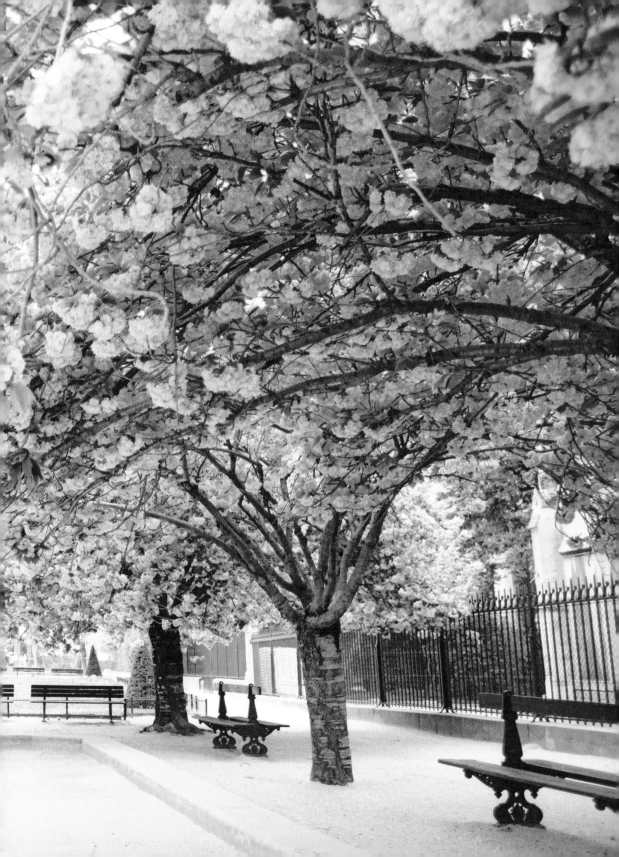

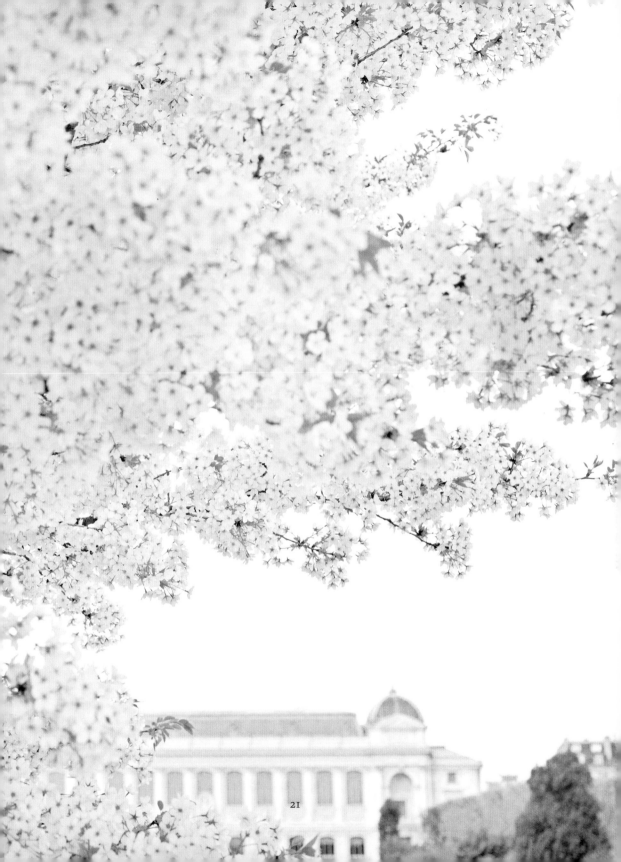

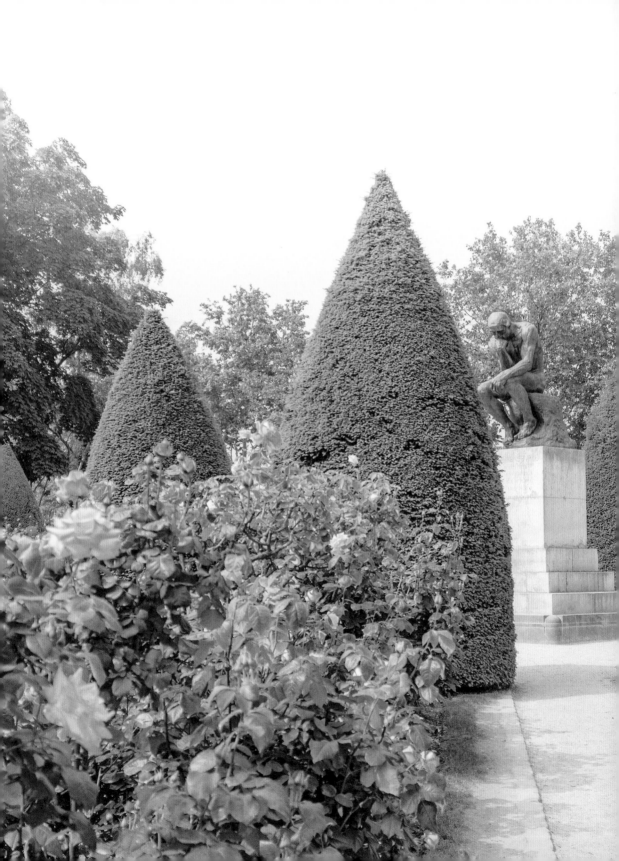

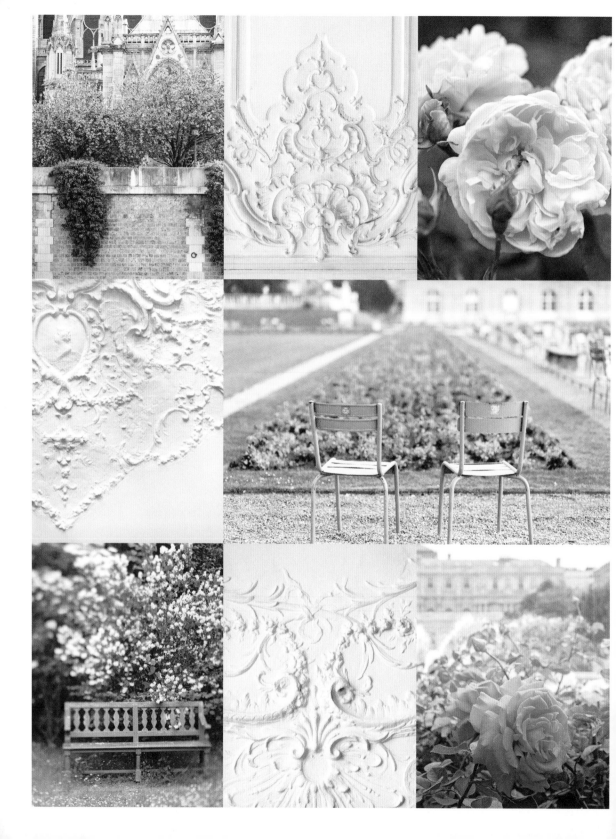

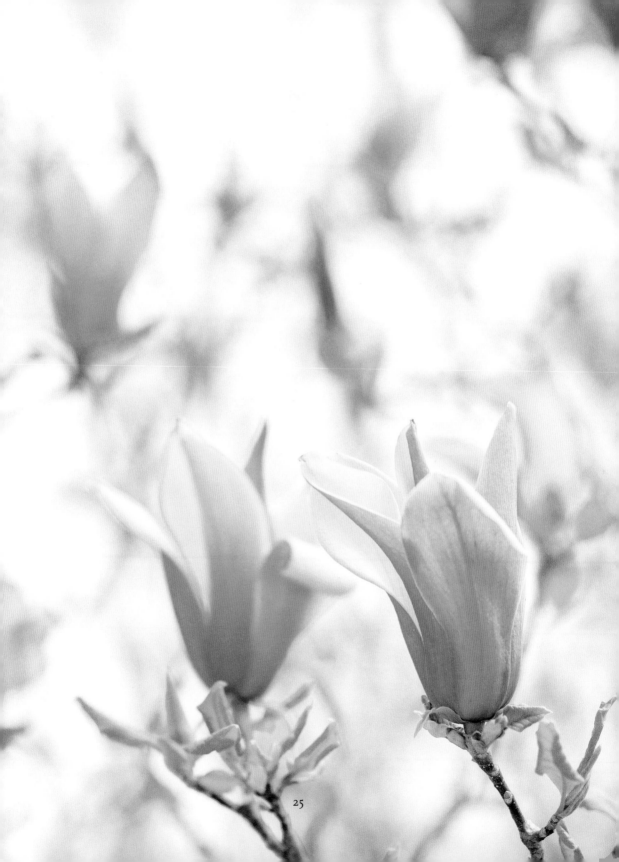

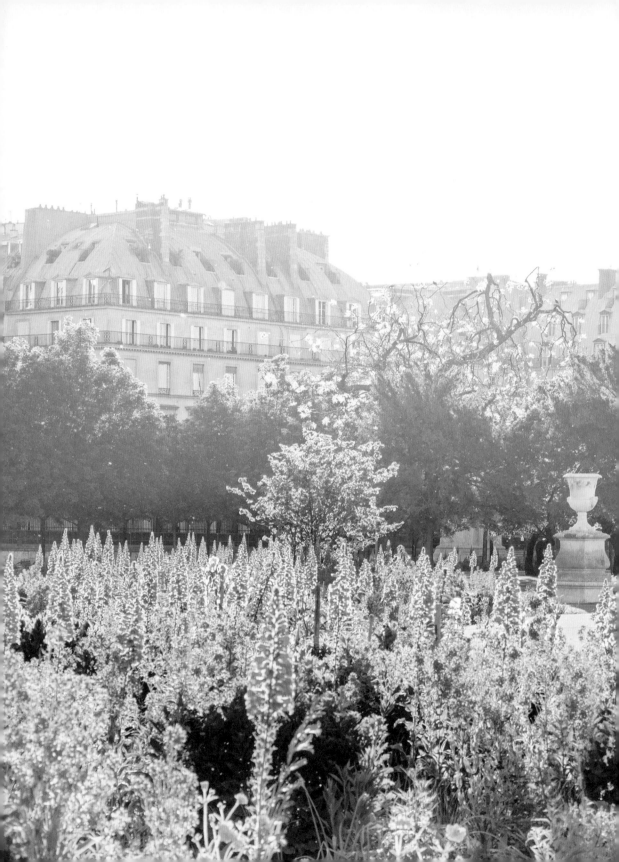

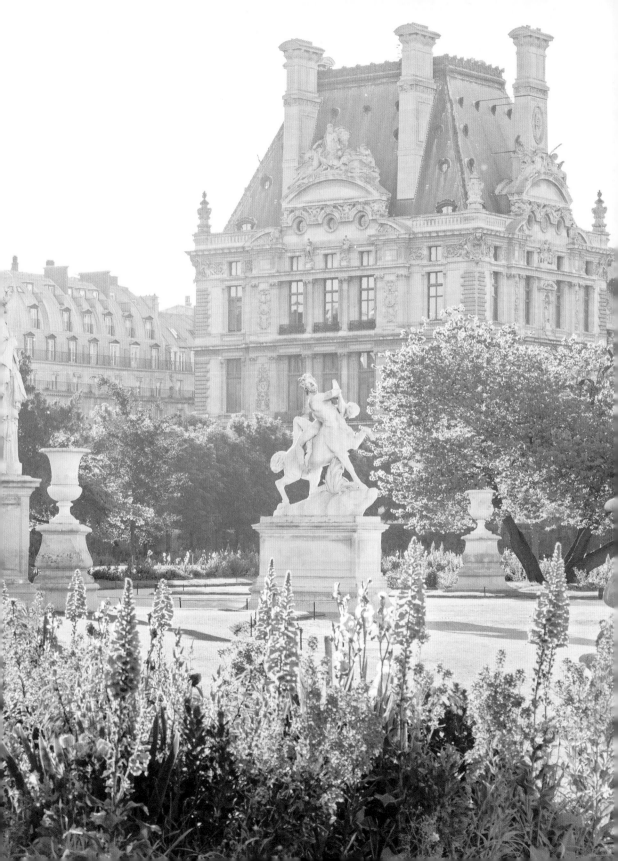

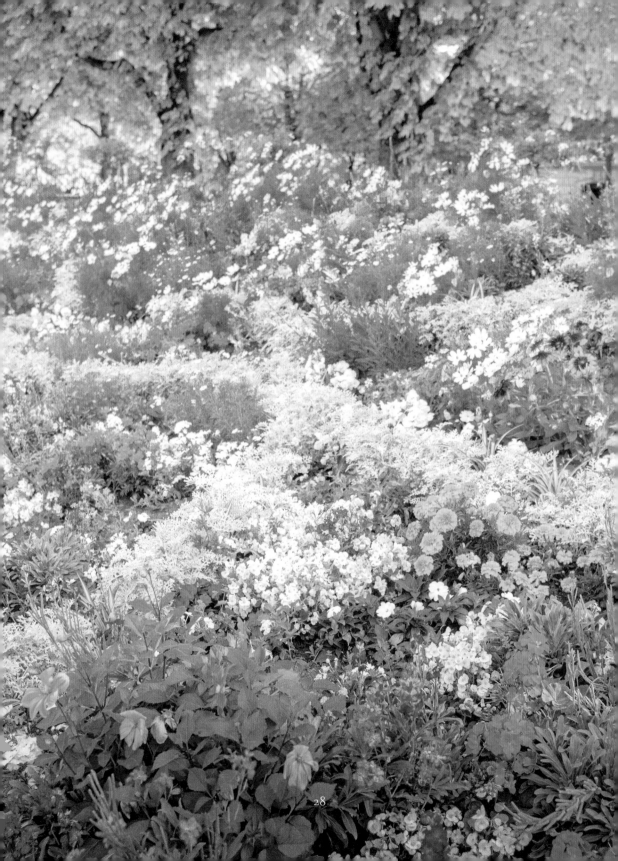

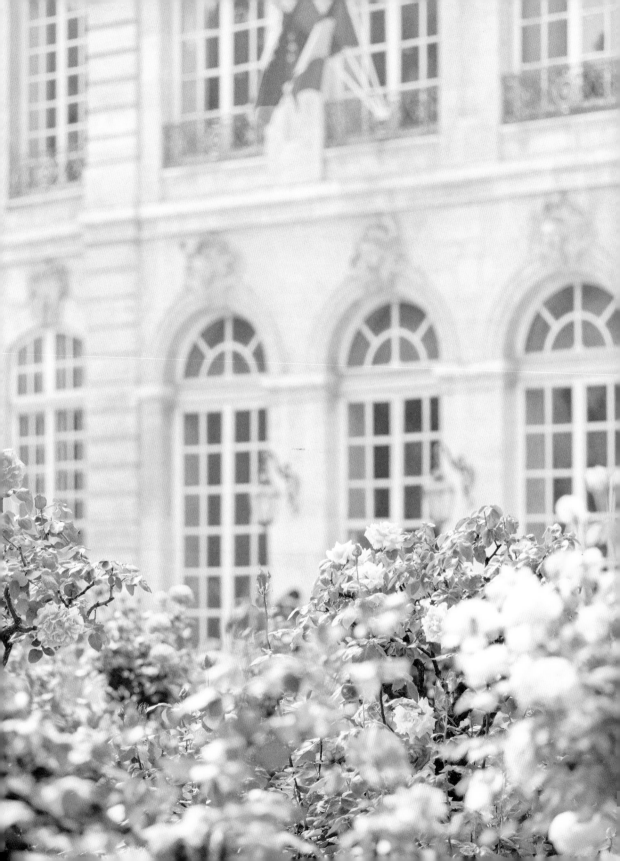

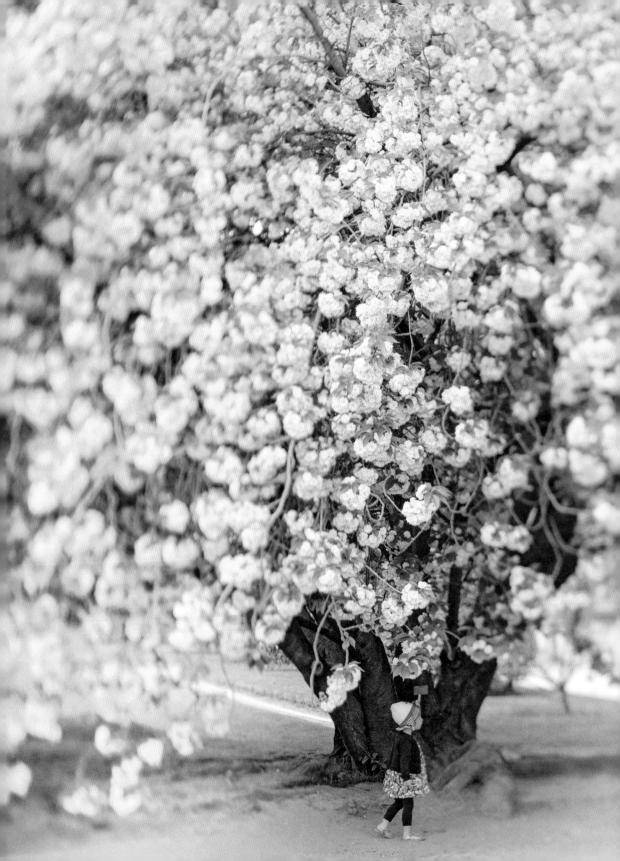

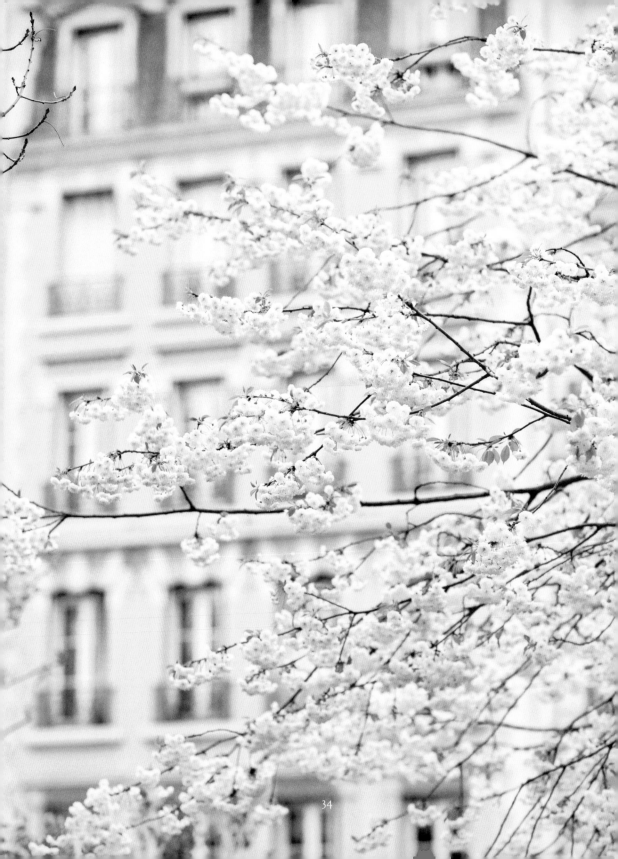

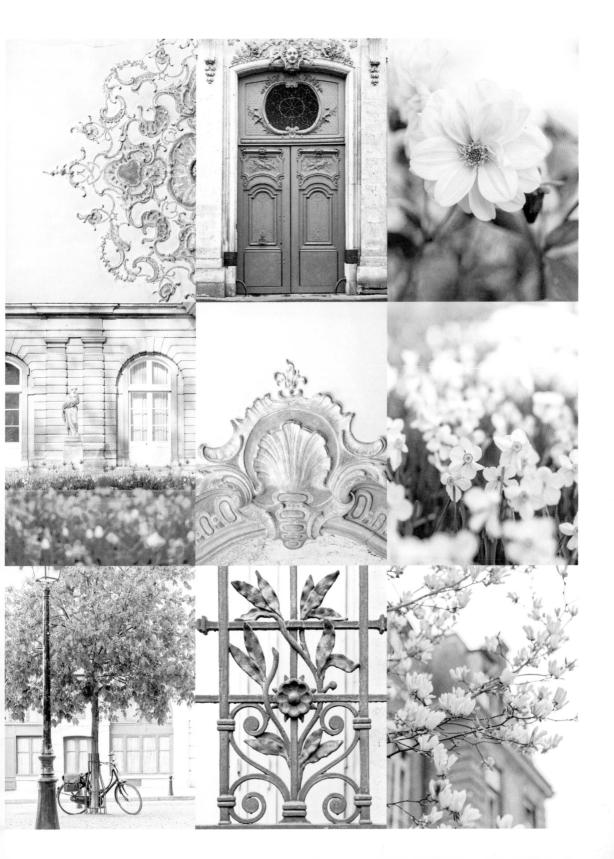

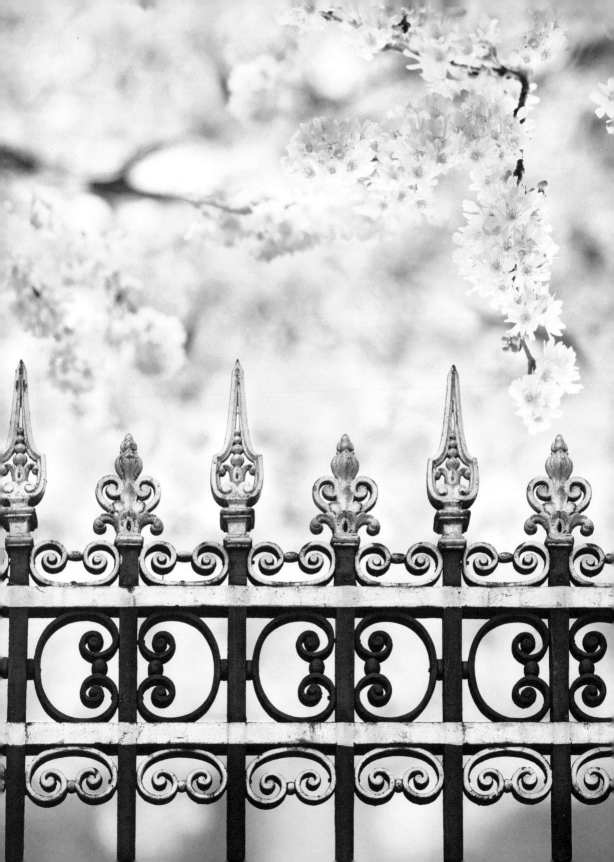

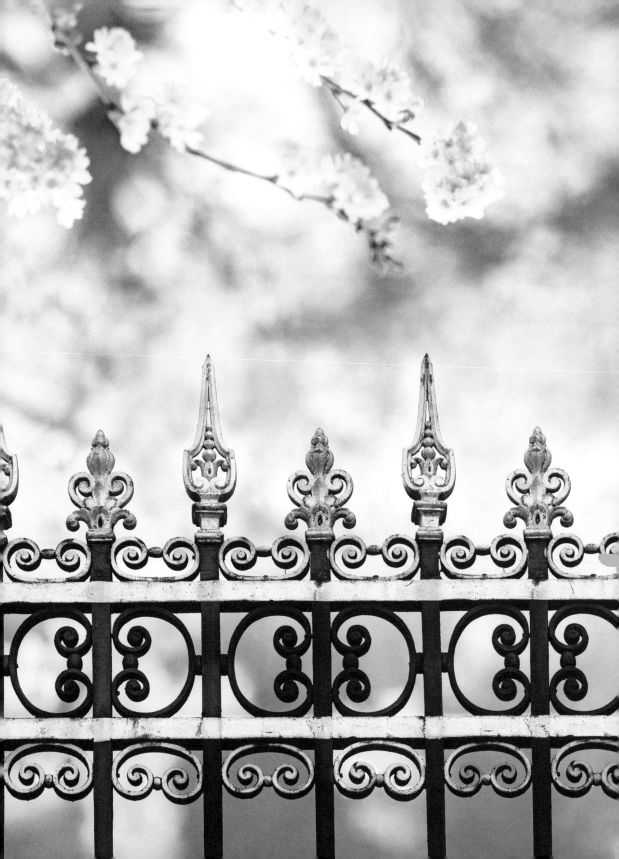

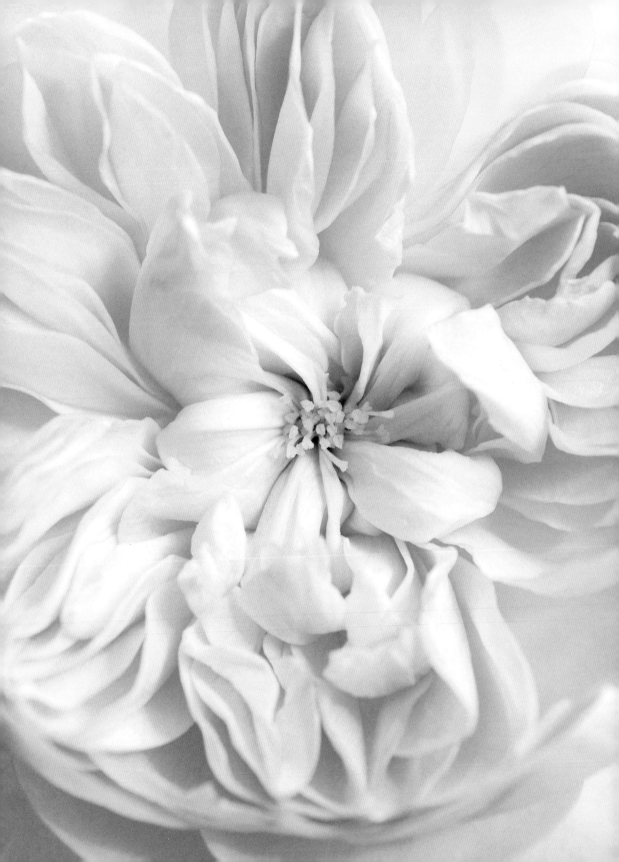

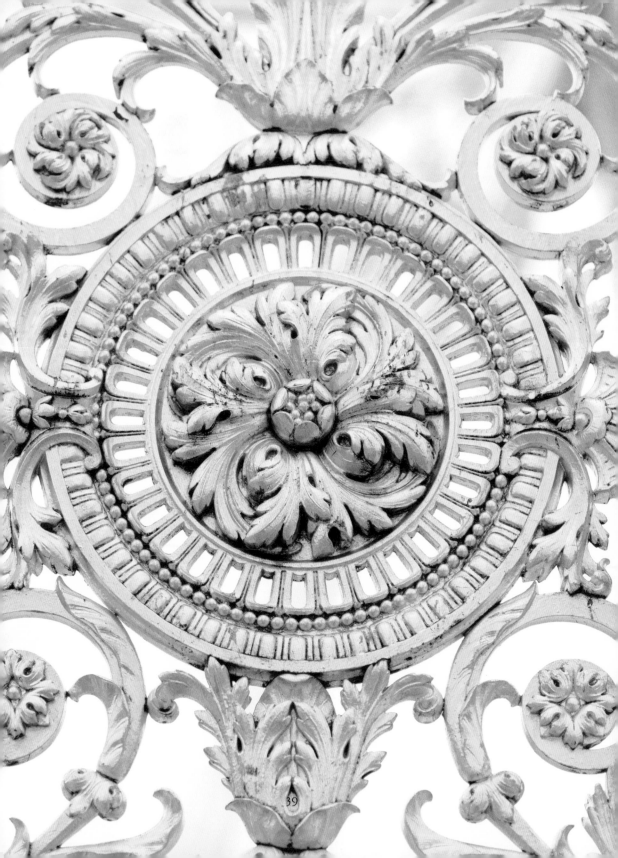

39

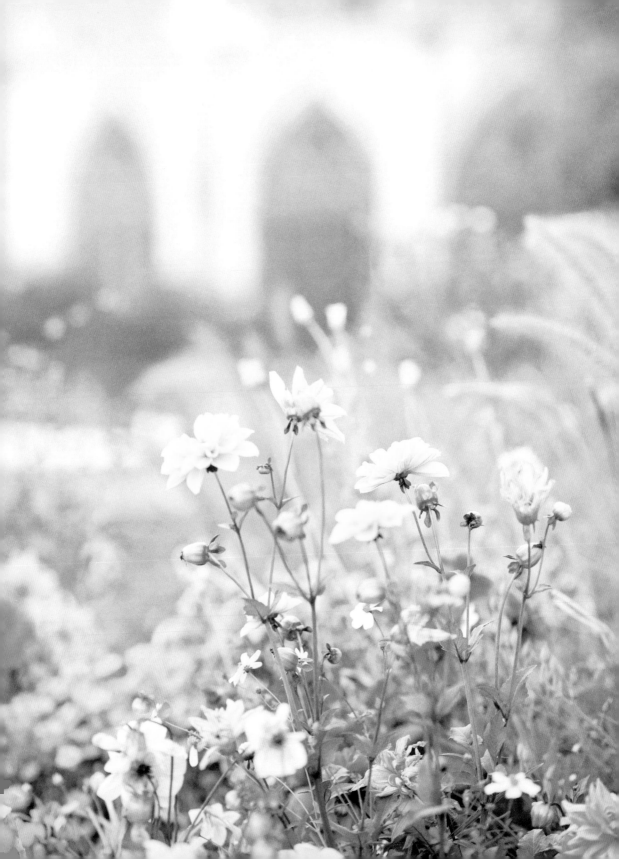

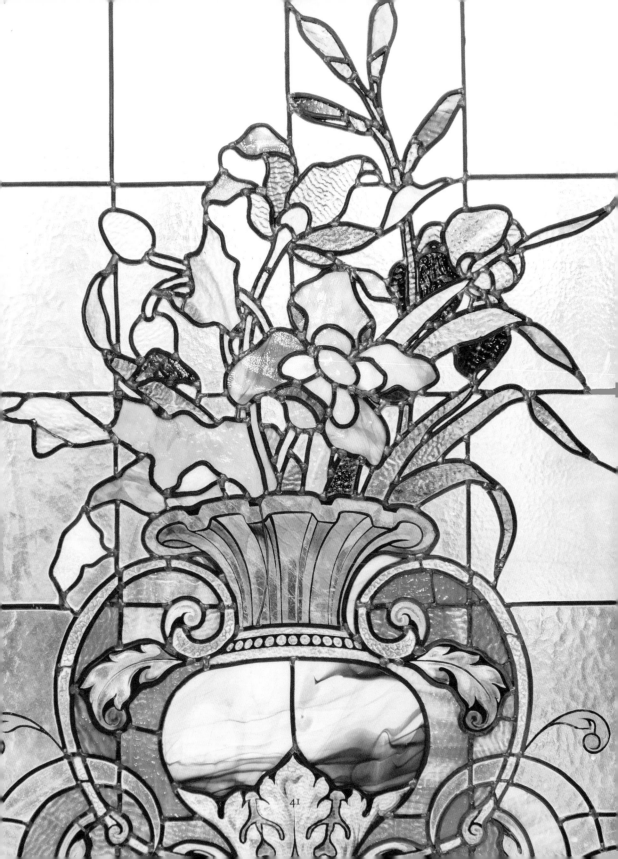

41

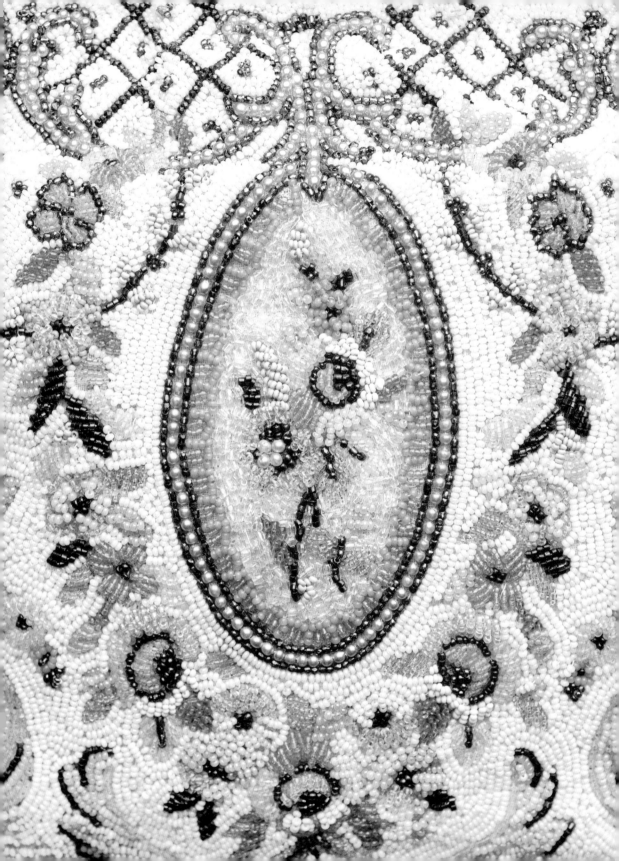

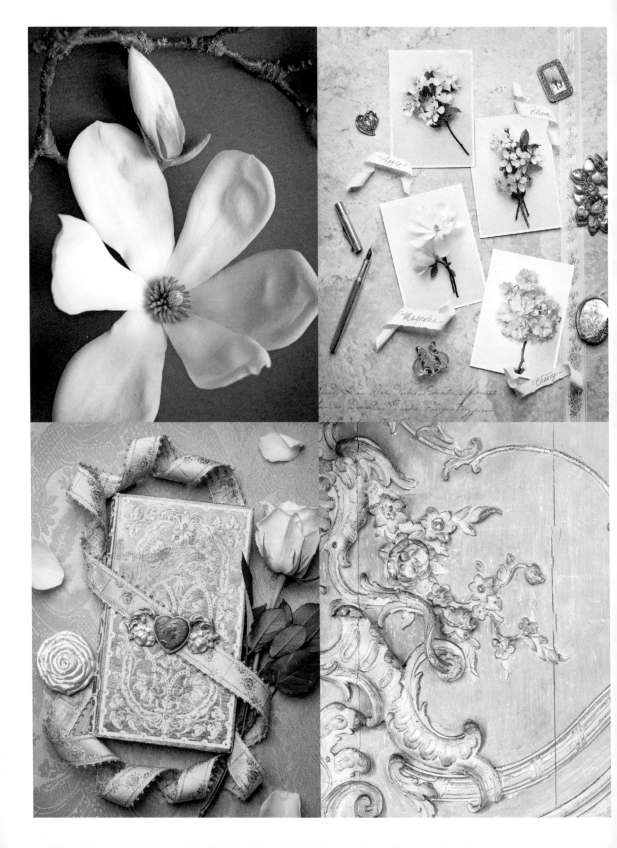

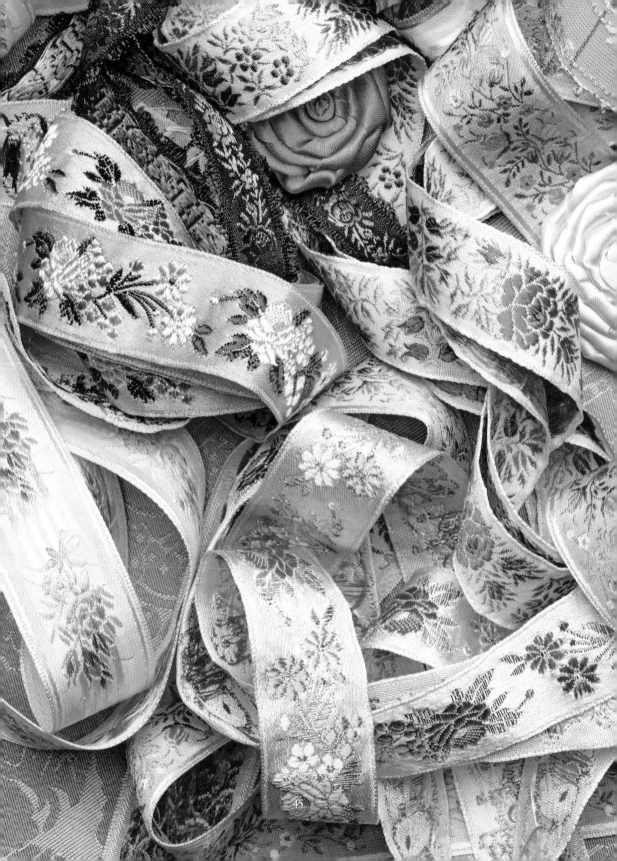

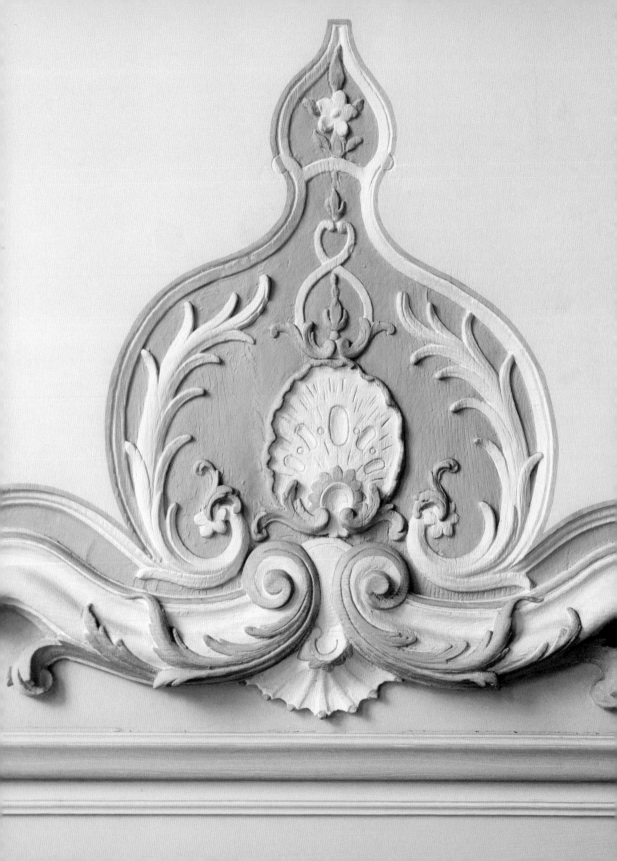

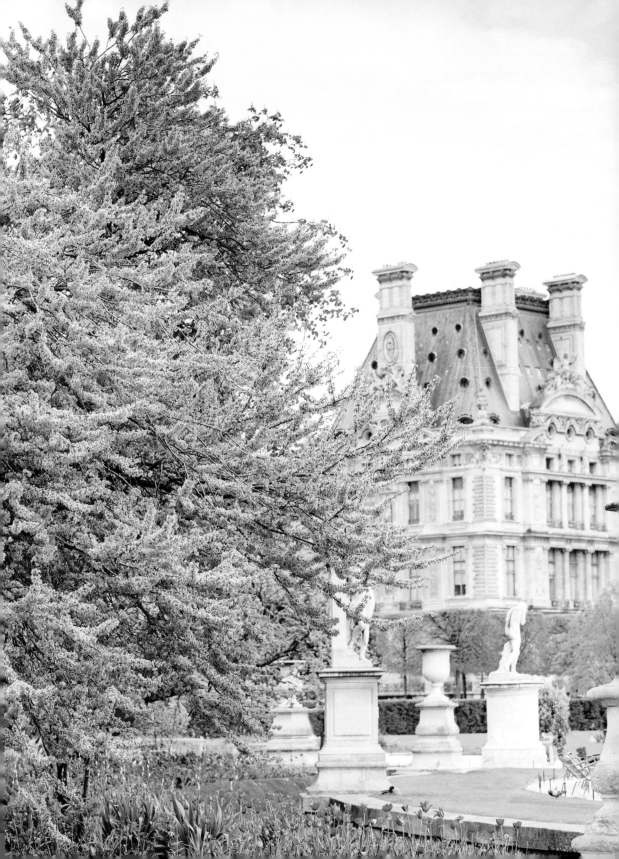

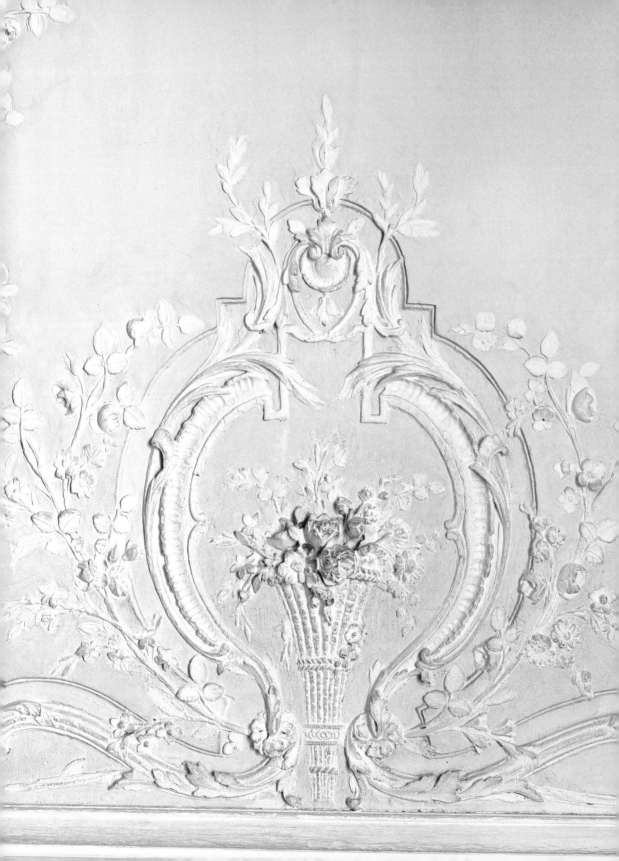

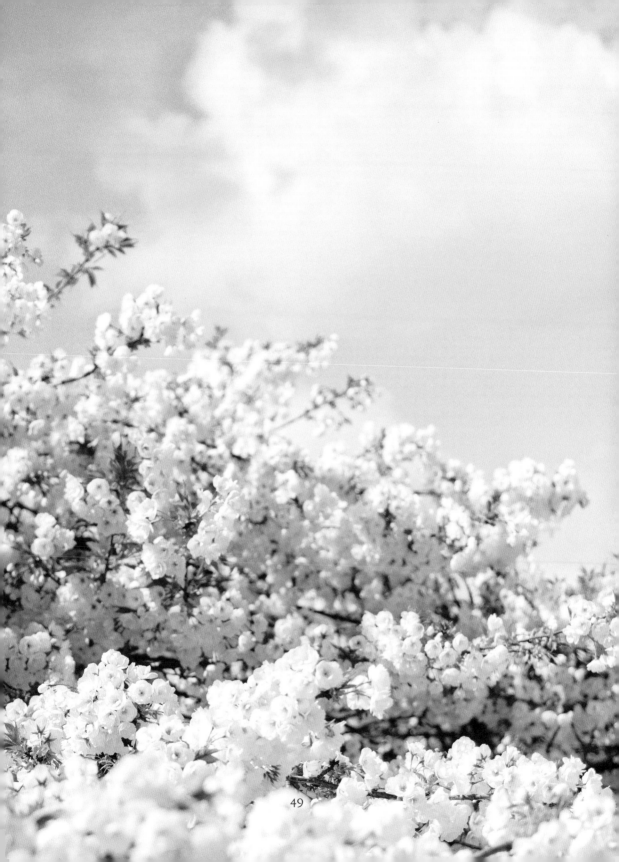

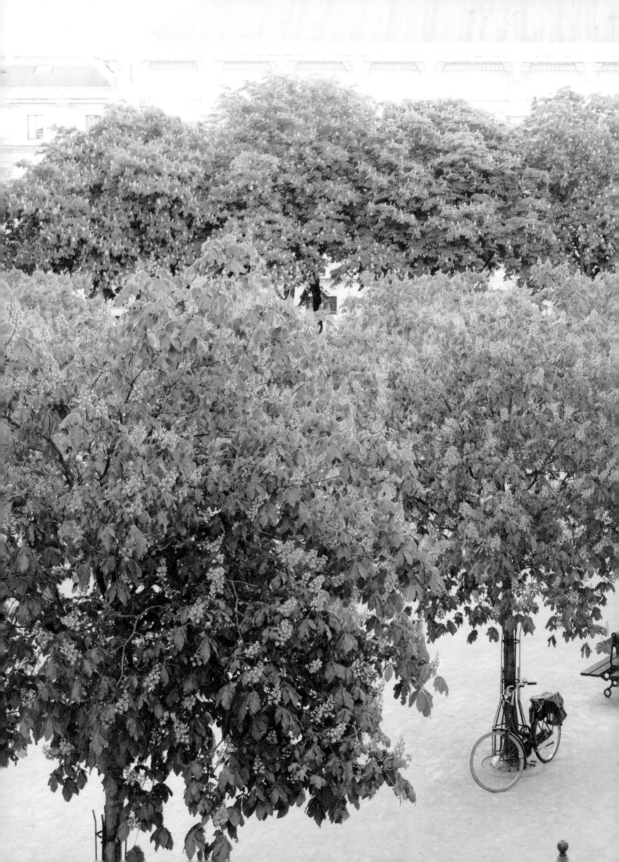

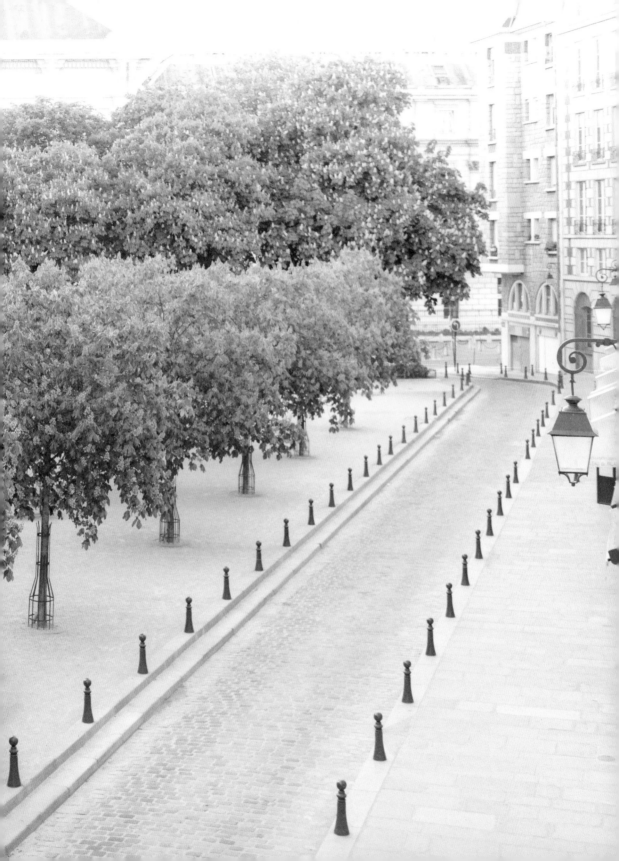

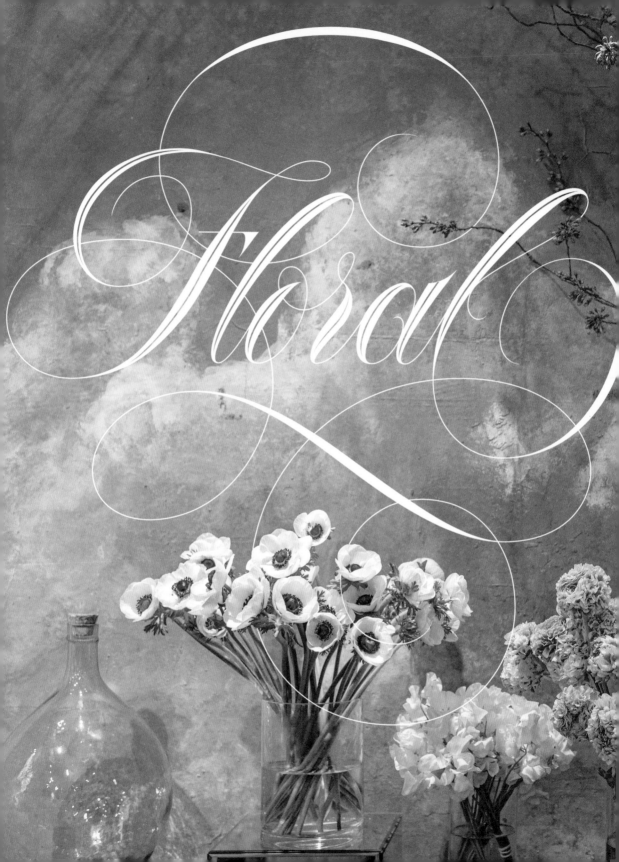

Floral

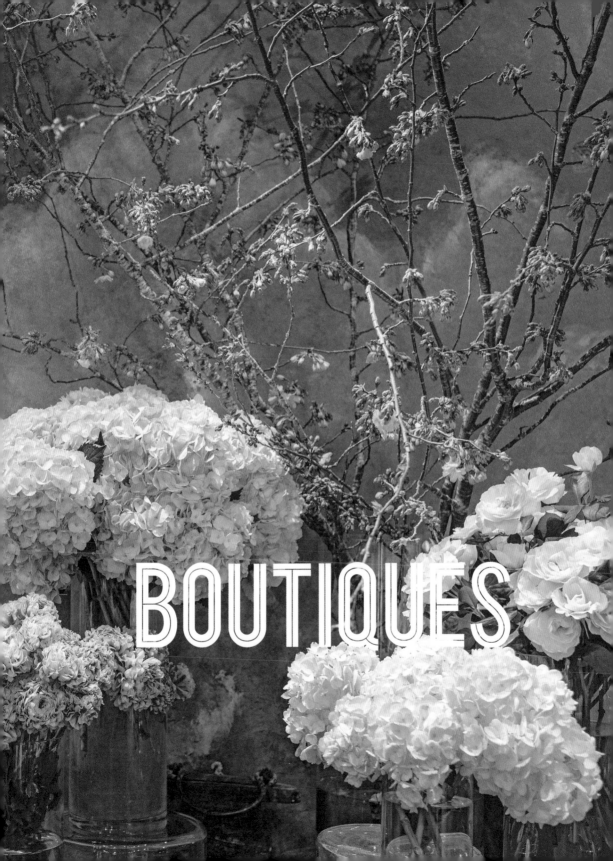

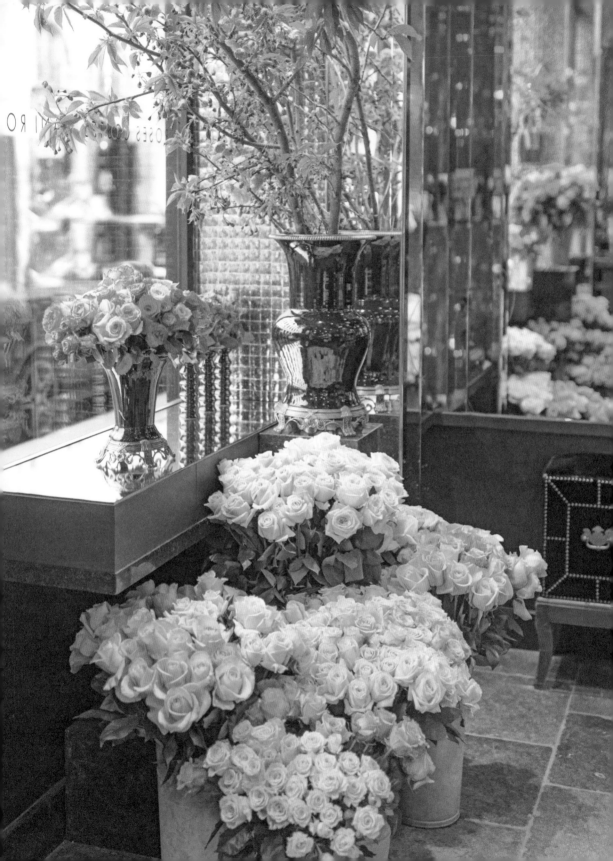

A long grand boulevards in Paris, gracing elegant squares or tucked down quiet side streets, you will find the floral ateliers and *boutiques des fleurs* of the city's best *artisan fleuristes*, the designers whose names are synonymous with glorious, blooming creations.

More than purveyors of flowers, the ateliers are destinations in themselves, stylish and beautifully appointed, with notable features distinguishing them from a more casual flower market.

Their charming exteriors boast artful displays that spill out onto the sidewalk in precise rows of coordinated containers. Props add a dash of sophisticated whimsy— old books, a garden statue or a vintage bicycle. Garlands drape across doorways and elaborate window arrangements command attention. One shop is known to slow traffic each spring with fifteen-foot-high, red-flowering camellia trees flanking its entrance.

Interiors are dramatic stage sets of painted murals, gilded walls, rich surfaces, polished metal vessels, antique dressers, vintage mirrors, and hand-blown glass bottles. Rose petals may be strewn about the doorway in a gesture of welcome.

Entering, you are surrounded by a panorama of floral abundance and fragrance. Take a moment to breathe in the joyful scent of a vase of double narcissus or freshly cut lilac.

Spotlights focus attention on the treasures lavished on every surface—ruffled sweet peas, textured poppies, lilies, ranunculus, dahlias, silken lisianthuses, feathery gerbera daisies. Stone urns overflow with lush peonies and blush-colored garden

roses. Puffy pink hydrangeas nestle among cherubs. Delicate, nodding fritillarias and hellebores and bright cheerful daffodils line a shelf strategically at eye level. The freshest, the choicest, the most magnificent of the season's offerings are proudly shown. Romantic and poetic presentation is their signature style, influenced by classic design and holiday celebrations, with due regard to the latest trends.

One corner will be devoted to flowers in a single color, such as a breathtaking cluster of mauve lilacs, hyacinths, and tulips, with the dark centers of anemones adding a punctuation mark to the overall effect. Another section will feature exotic orchids, ferns, and palms or tall, bending stems of calla lily and amaryllis that lean out of slender glass cylinders, creating unusual sculptural shapes. And even the simplest arrangement will impress, such as a single rose bud with a mantle of moss in a tiny zinc vase.

Spring is most enchanting, when massive flowering branches of cherry, plum, and apple are brought in to create arching canopies of blossoms.

The regular clientele of these boutiques is likely to include locals residing in elegant Haussmann apartments, celebrity brides, or fashion designers requiring lavish floral installations as backdrops to their latest collections. But casual passersby are also welcome to wander in and revel in the splendid environment while choosing the ingredients for their own custom creations.

Selecting the components for a bouquet is never a hurried activity, and clients are encouraged to explore the wealth of exquisite blooms and envision the perfect arrangement. It is a hushed and intent undertaking. Will it be roses? Perhaps a few stems of coral peony or a handful of fringed tulips accentuated with eucalyptus and pussy willow? Which foliage will be the ideal complement? *Quelles couleurs? Pour une femme? Un anniversaire?*

After careful consideration of color, form, and shape, with perhaps a few recommendations from the staff, your choices are made. The stems are then lovingly prepared, precisely arranged together; wrapped in thick, textured paper; and tied with beautiful ribbon. And when your fancy parcel is placed in your hands with flair, you stride out the door with a bounce in your step and an irrepressible smile on your face, feeling as stylish and classy as the shop itself.

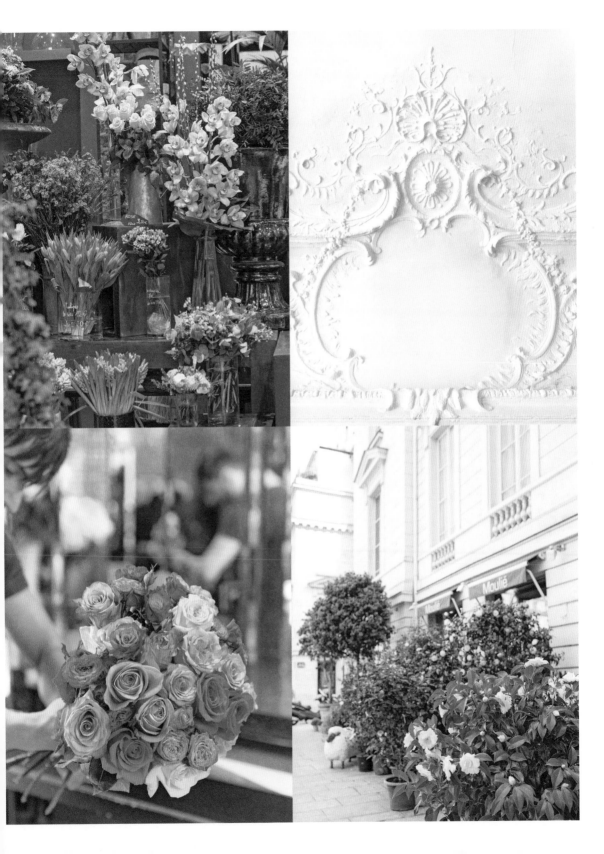

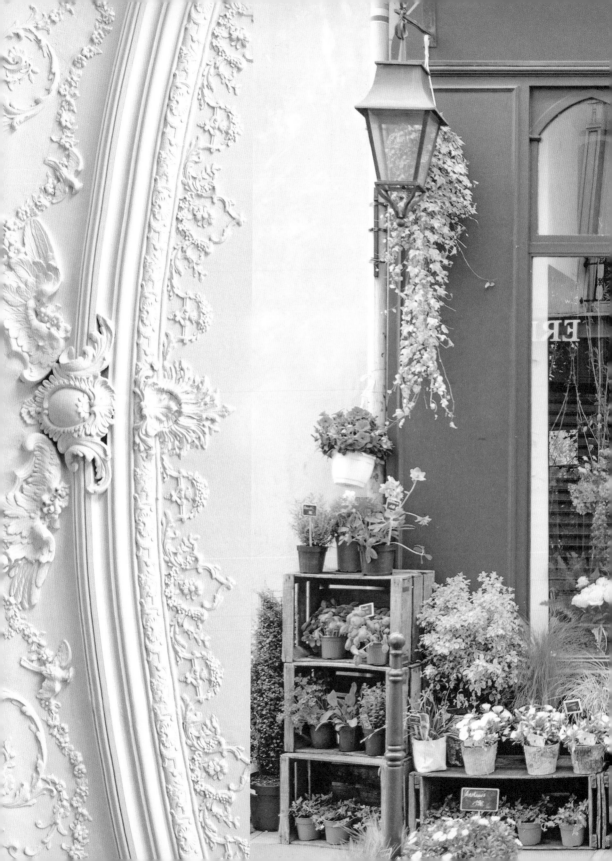

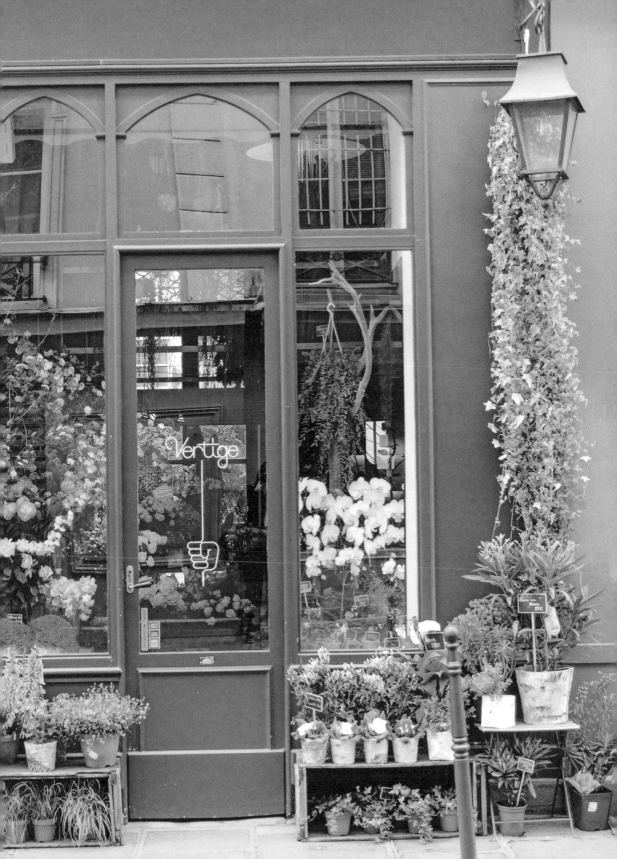

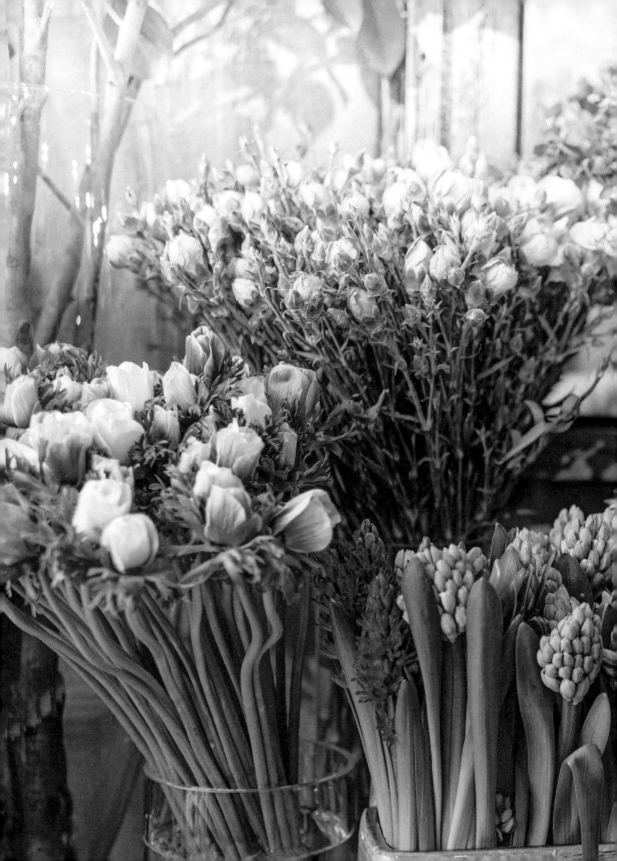

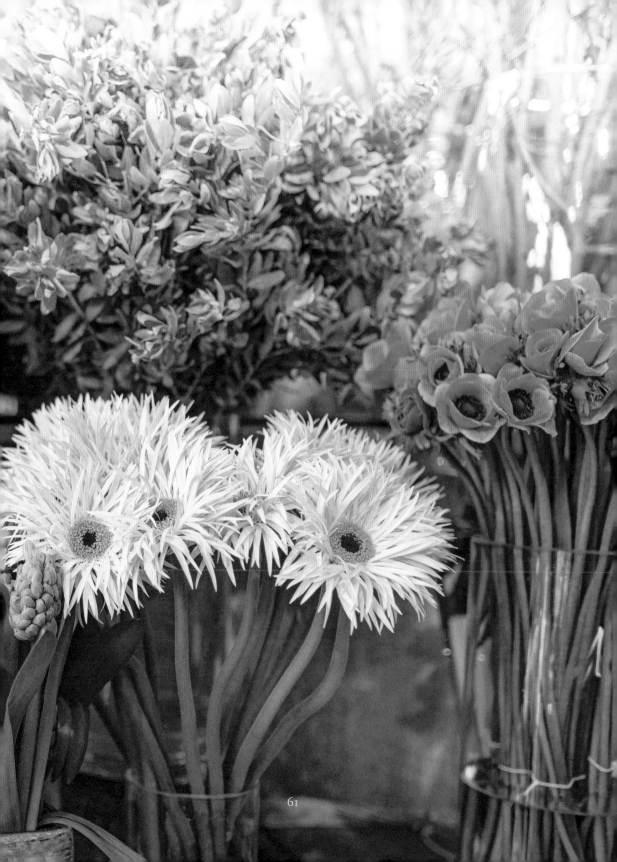

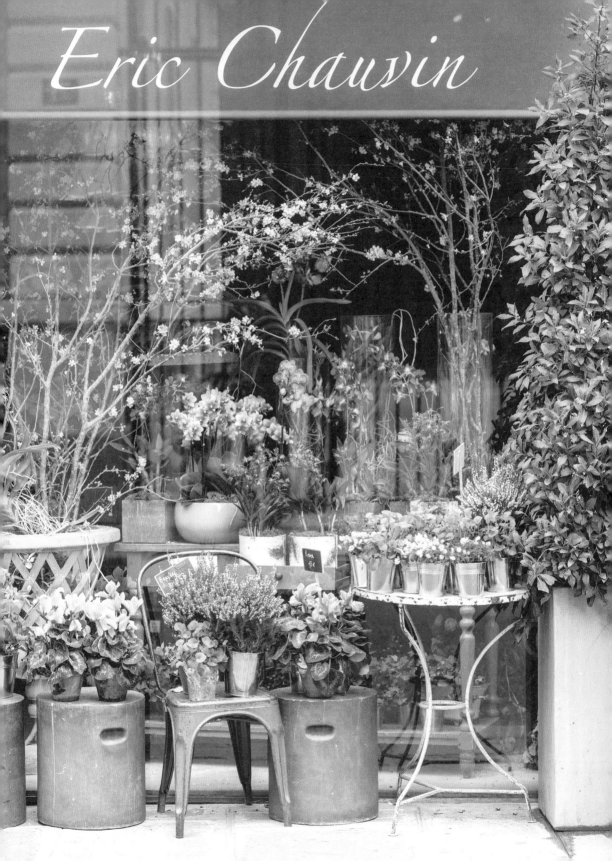

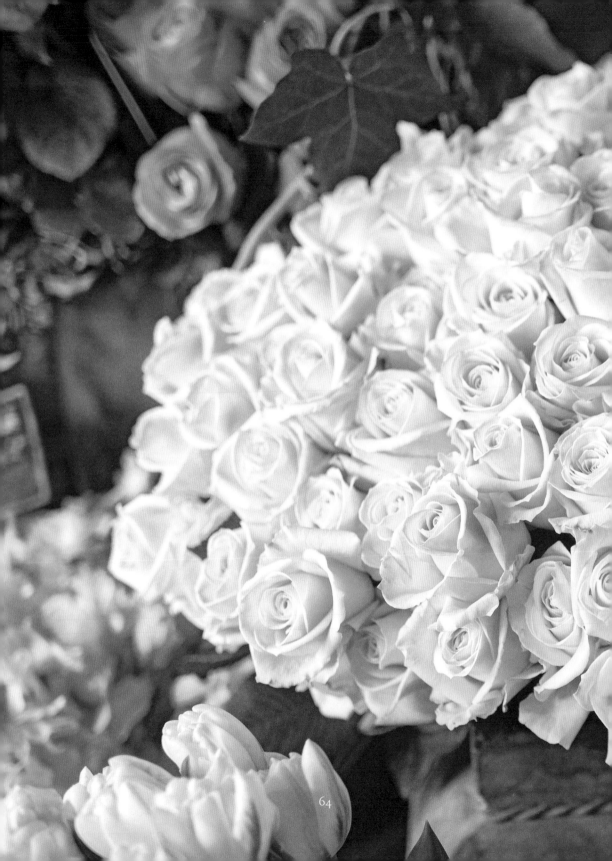

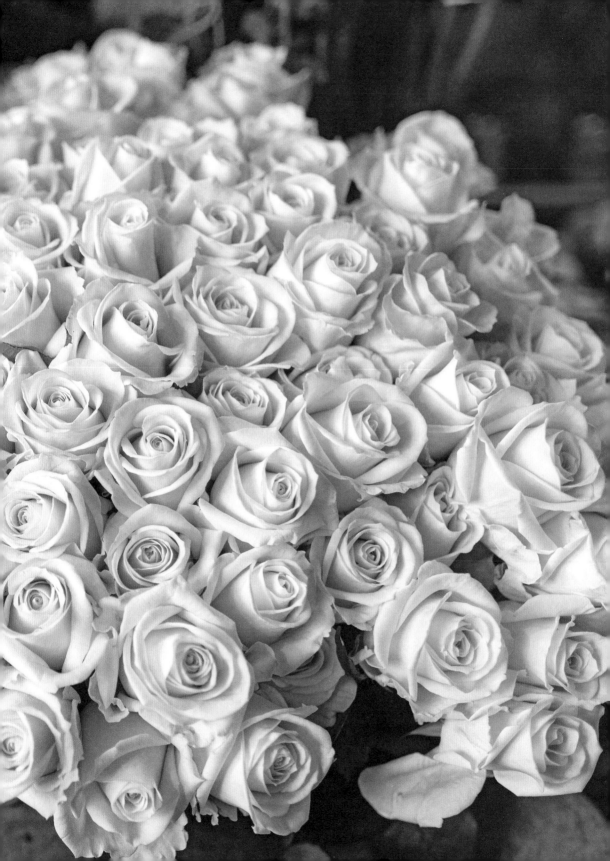

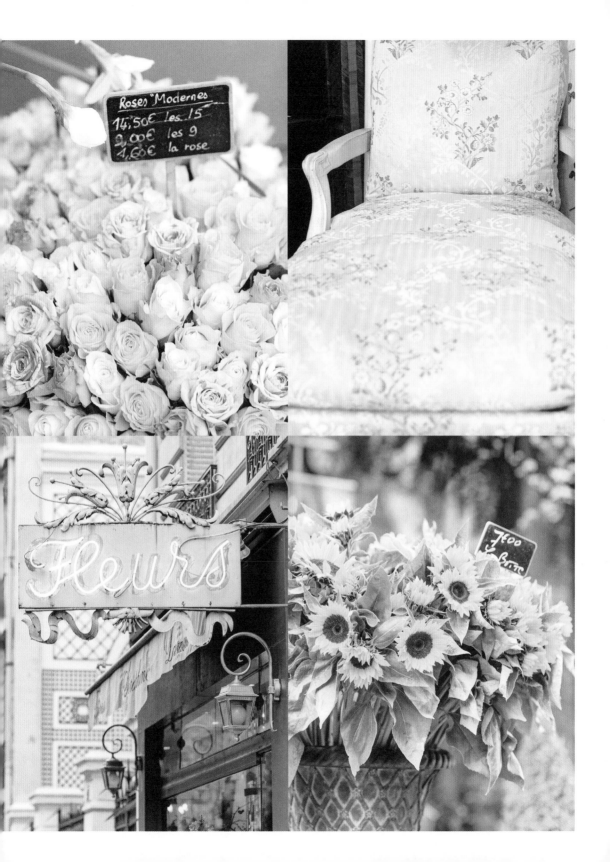

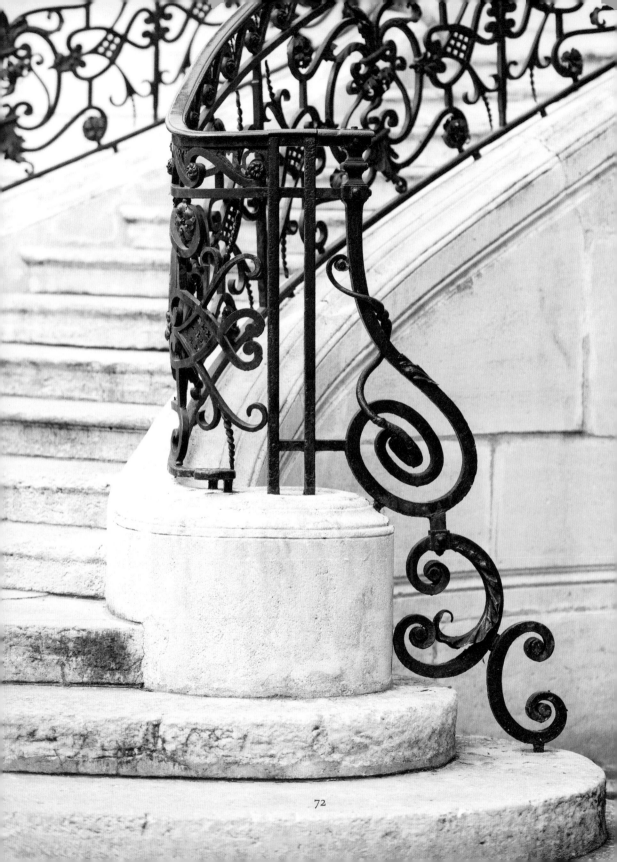

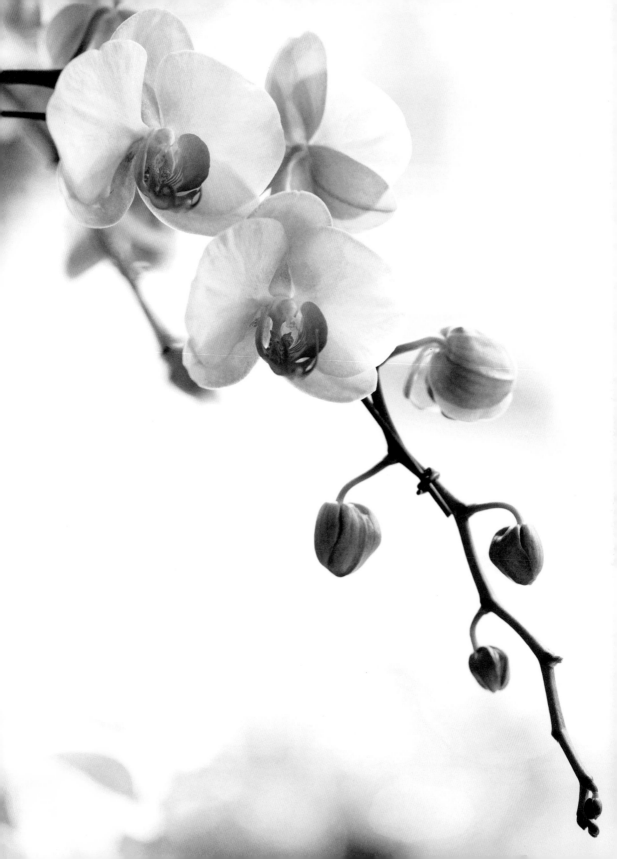

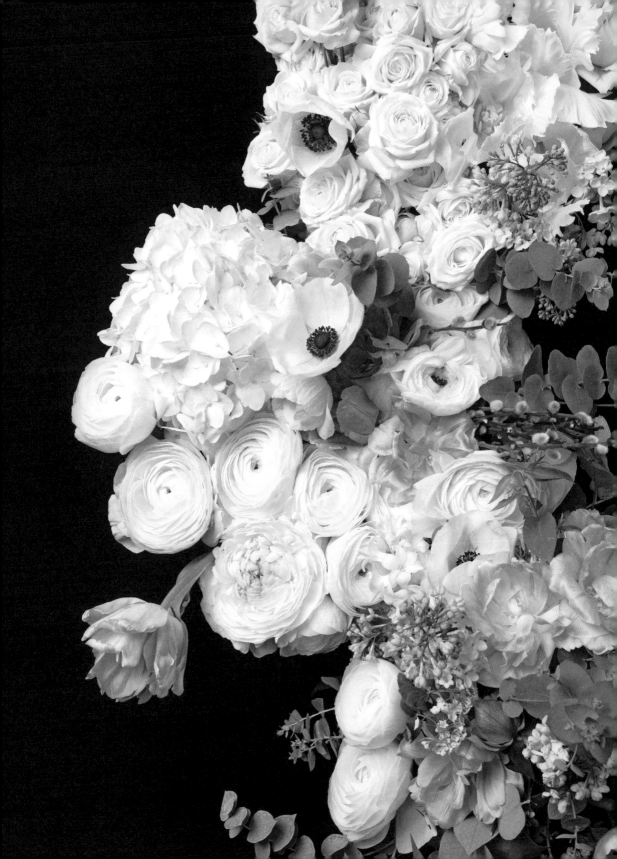

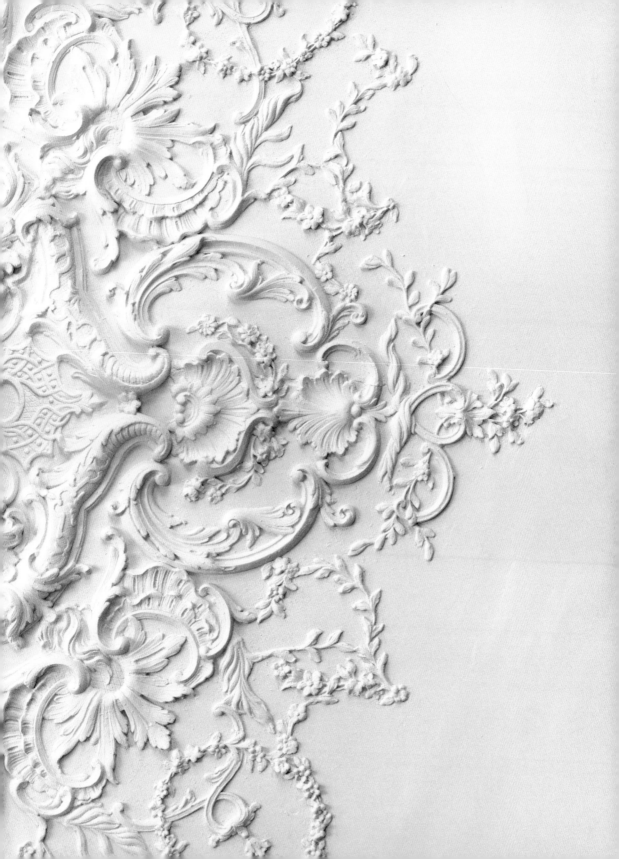

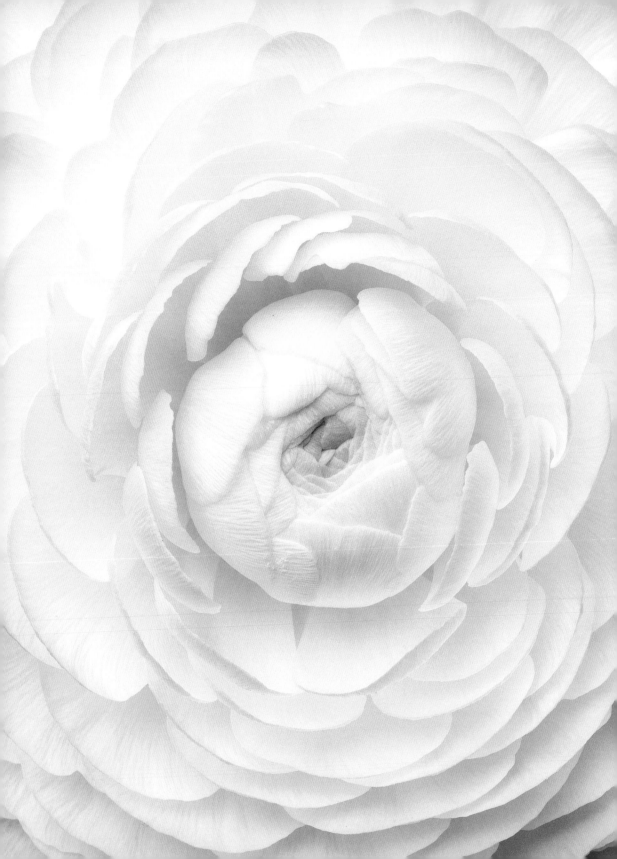

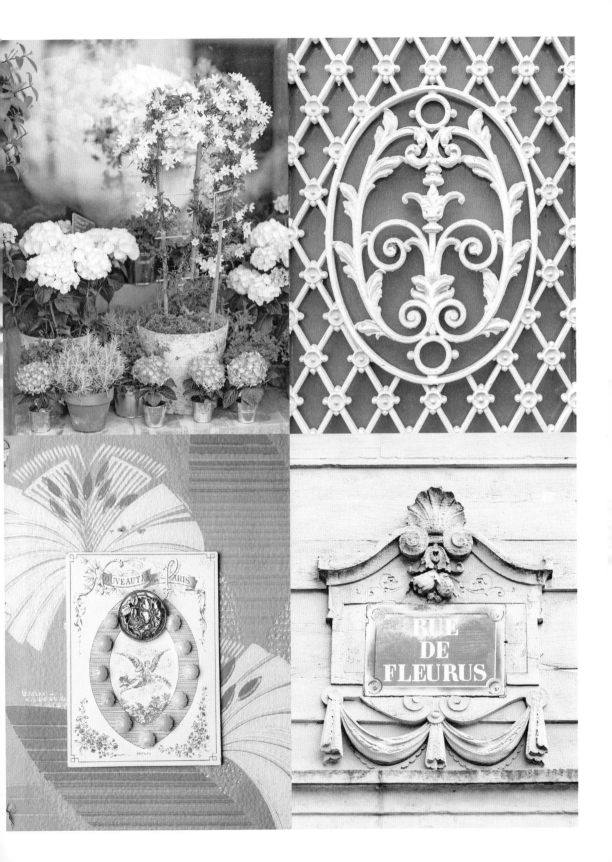

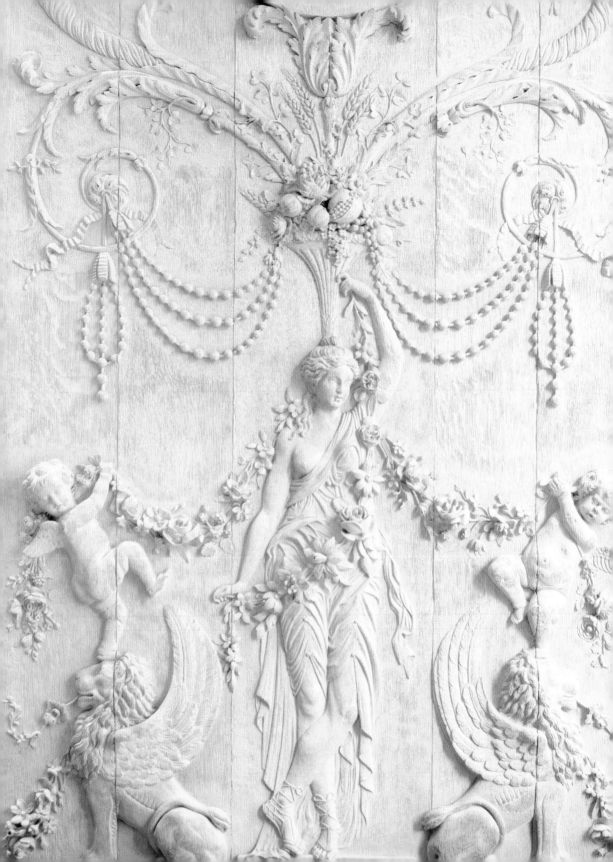

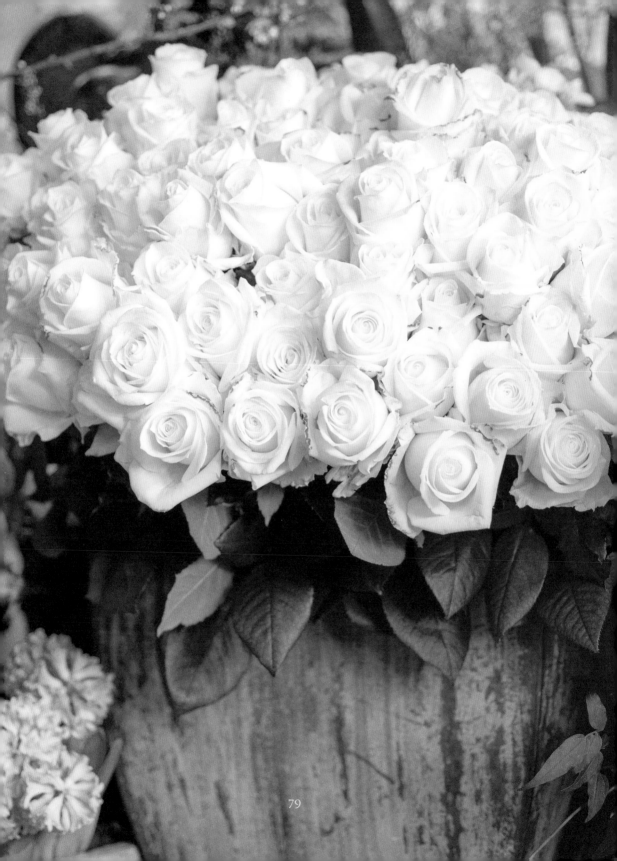

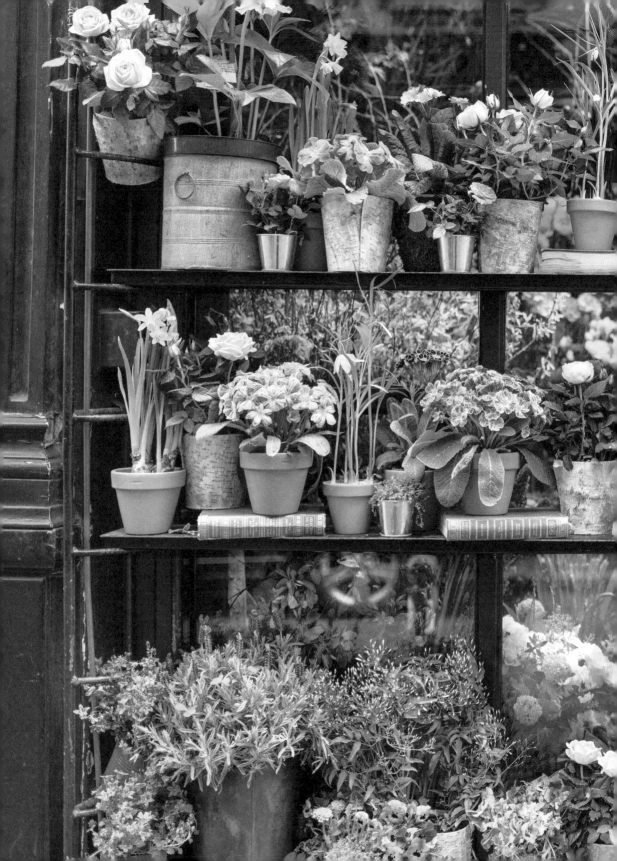

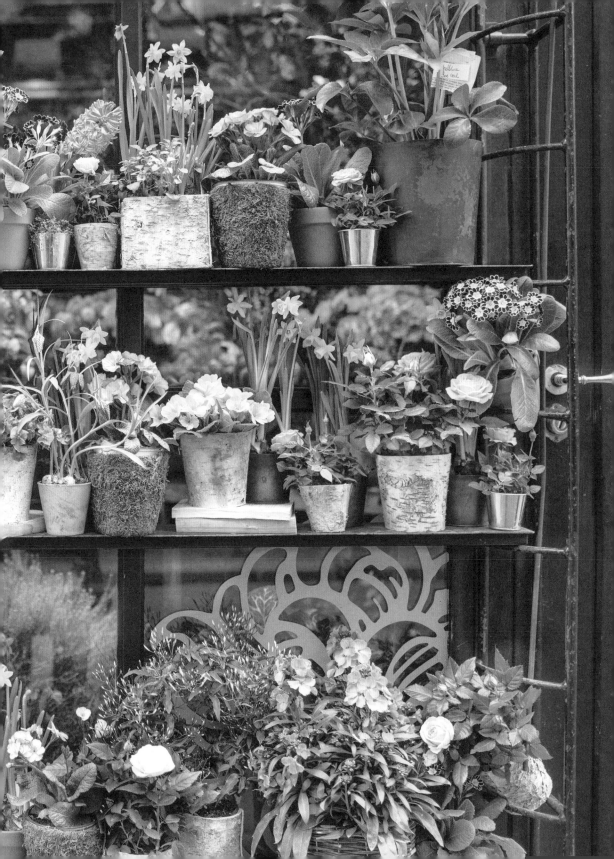

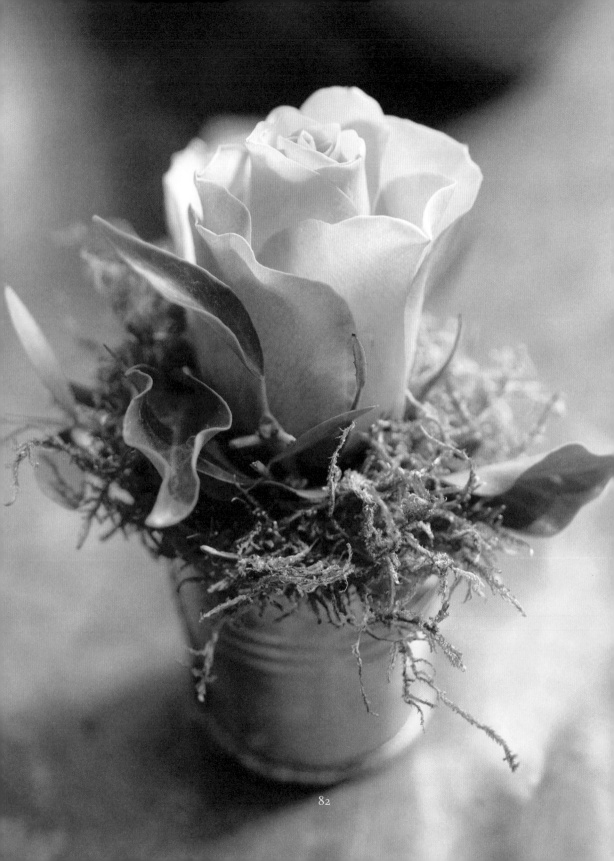

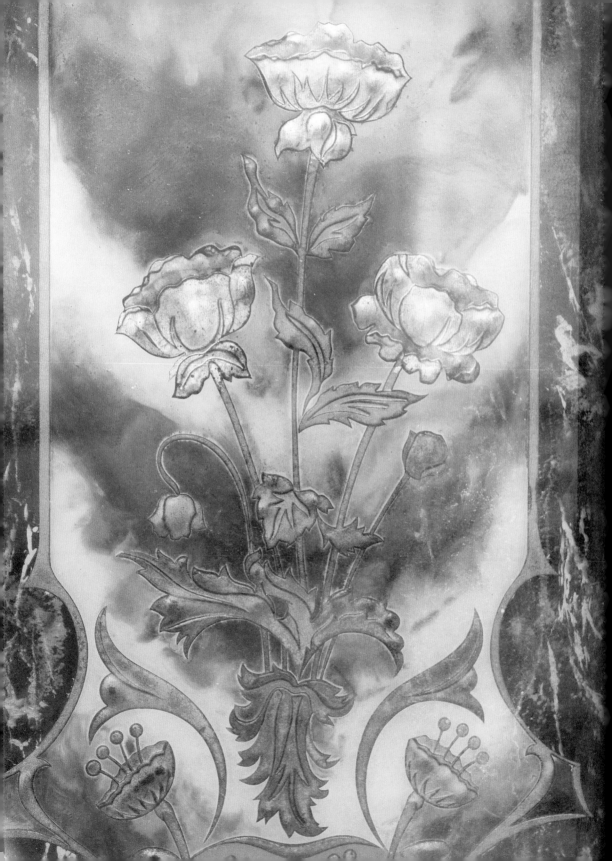

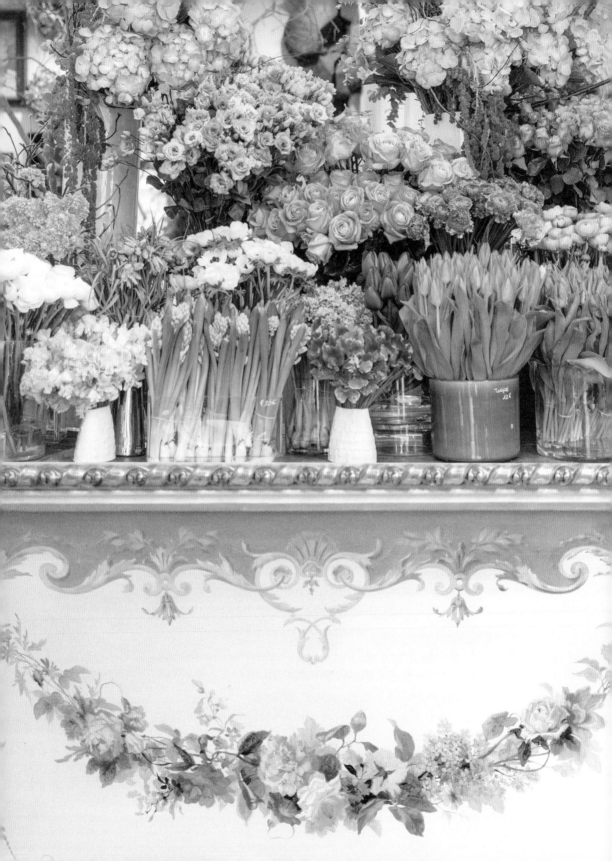

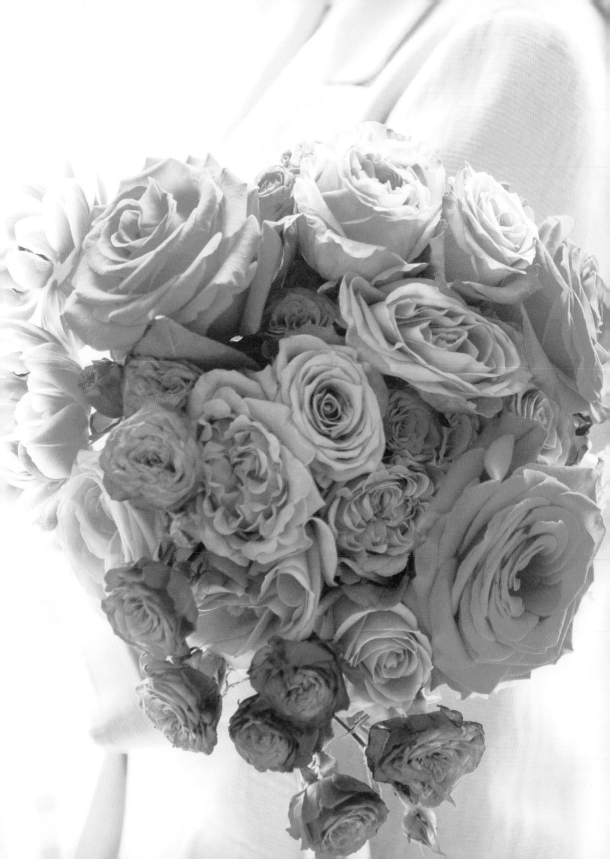

MARKET

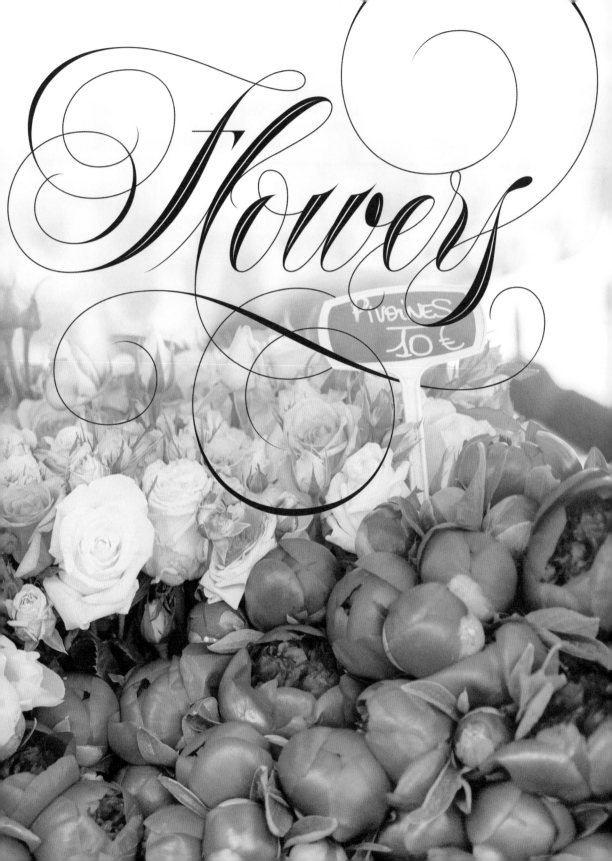

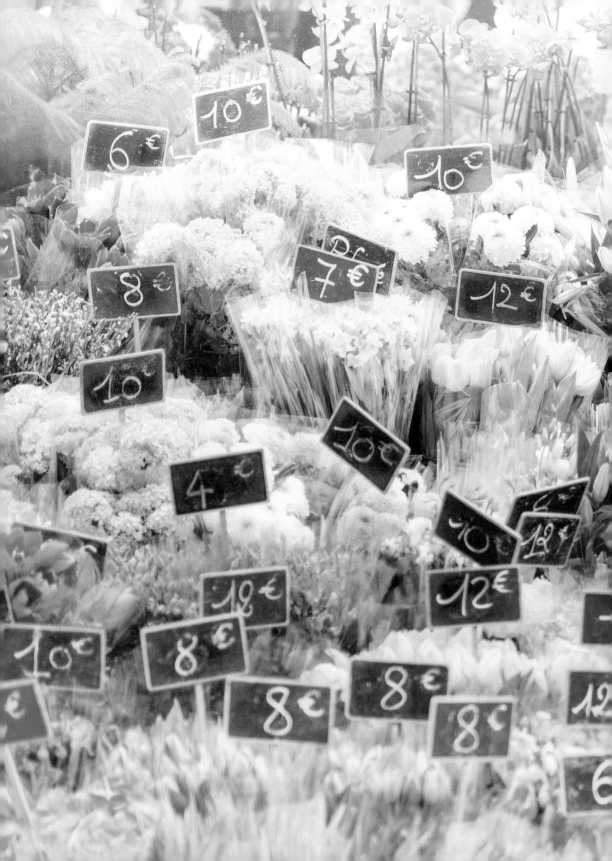

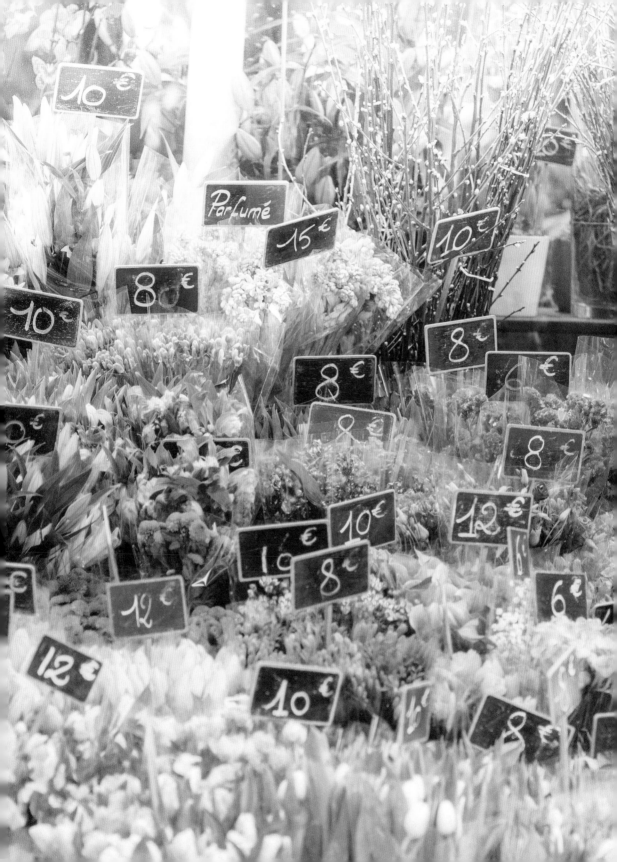

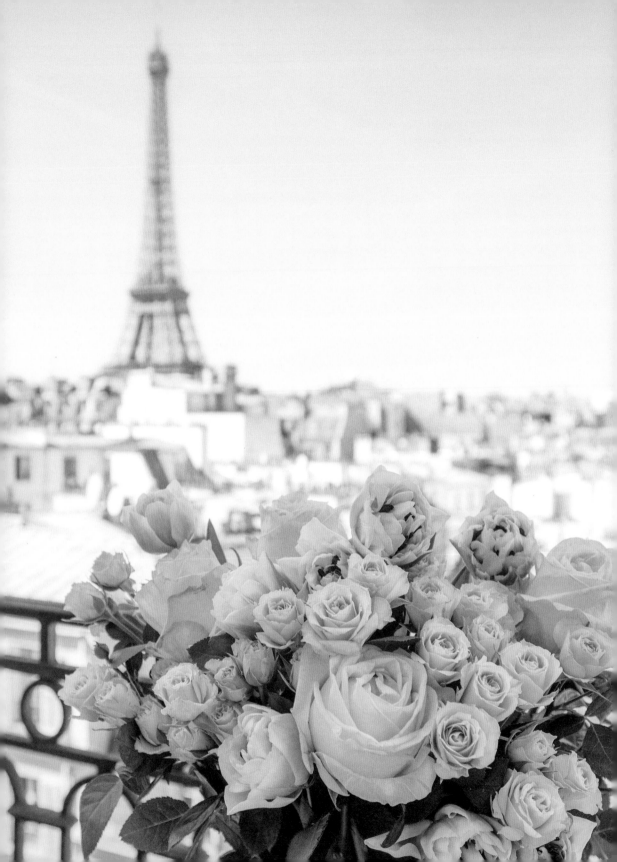

A baguette, cheese, wine—all basic purchases on a routine visit to a local market in Paris. And to that list, we must add *flowers*. While they may not be strictly necessary to survival, to a Parisian, they are a vital part of daily life. With their refined senses of style and grace, most residents know that flowers bring life, fragrance, color, and beauty to the home and work space and that they never fail to bring joy and a sense of well-being.

One has only to observe the deliberation with which market goers choose individual blooms, comparing complementary colors and appropriate foliage accents with deep concentration, to realize the importance of bringing home just the right combination.

Every neighborhood market has at least one stand, and more likely several, selling cut flowers, small potted plants, fillers, and everything you might require to create your own bouquets at home. Artistically arranged, towering mounds of brilliant color, intricate form, and heady scent greet market goers: narcissi, gerbera daisies, still-budded hyacinths, trumpet lilies, potted azaleas, dahlias, asters, sunflowers, anemones, and cyclamens all cluster together with bright, almost-neon colors that rivet attention. And always, in any month of the year, there are roses.

The major twice-weekly markets, such as the Marché Bastille on Boulevard Richard Lenoir, Marché Président Wilson, and Marché Maubert, reliably offer the freshest seasonal plants and cut flowers. Each is worth a visit just to marvel at the gravity-defying walls of peonies, tulips, roses, and ranunculus—big, voluptuous piles of delicate-petaled beauty.

If you're searching for just the right potted plant for your *petit* Parisian balcony, Marché aux Fleurs is a prime destination. Violets, camellias, primroses, cyclamens, geraniums, hydrangeas, hibiscuses, roses, azaleas, and rhododendrons are available, stacked to the ceiling on bleachers. Numerous stalls sell cut blooms, container plants, shrubs, trees, garden-themed gifts and accessories, seeds, and much more. This historical market has thrived in the same location on the Île de la Cité since the 1800s. Formerly known as the Marché aux Fleurs et aux Oiseaux Cité—Sunday features a bird and small-animal market—it was rechristened in 2014 and is now known as Marché aux Fleurs Reine Elizabeth II, renamed in honor of Queen Elizabeth II just after the seventieth anniversary of D-day. Orchid lovers will be in heaven visiting the corner shop dedicated to the species. But even if you're not shopping, a stroll among the hanging baskets and colorful presentations is a pleasant break from sightseeing on the often-crowded island.

Not far away, a comprehensive range of flowers, house plants, small trees, and shrubs can be found along a stretch of Quai de la Mégisserie known for its floral outlets. Walking along the Seine, you can't miss the tables loaded with cyclamens, geraniums, and primroses.

Always enjoyable and scenic are the permanent walking streets of rue Cler in the 7th arrondissement and rue Montorgueil in the 2nd arrondissement, both of which have wonderful flower sellers who can be relied upon for their rainbow-hued displays and almost overwhelming selections. On Sundays, settle in to a café opposite the flower shop and enjoy sweet scenes of elegant, elderly gentlemen carefully choosing the perfect bouquet or children emerging clutching tiny nosegays.

For the ultimate floral-market experience, arrange for a predawn visit to Marché International de Rungis, the gigantic wholesale market outside Paris, with a professional florist. There, vast collections, fresh from private and commercial growers in France, Holland, and all over the world, spread out in a colorful patchwork of fragrance and pattern.

No matter where in Paris you find yourself, on the Left Bank or Right, Montmartre or Montparnasse, a marvelous market will be nearby—with a tempting assortment of beautiful blooms to bring fragrance and loveliness to your home or hotel room.

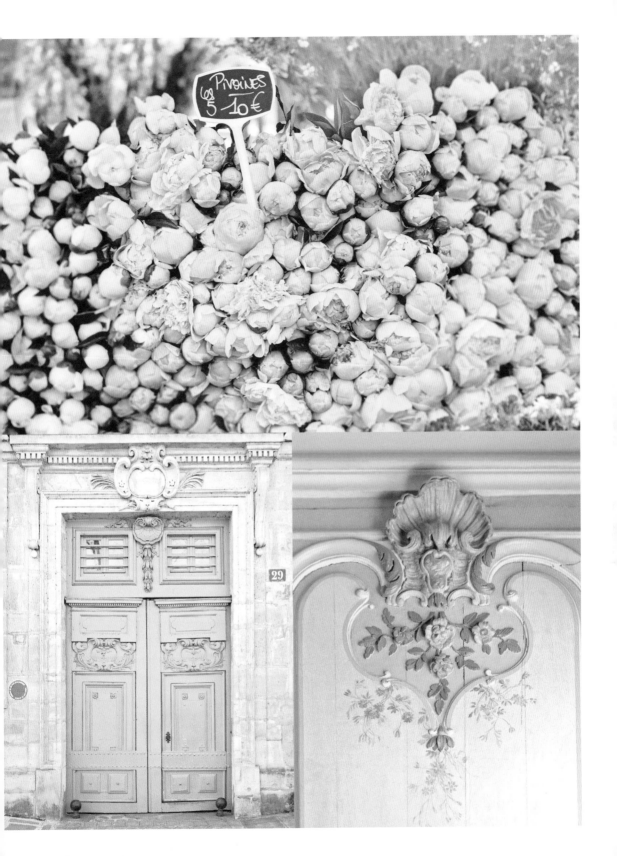

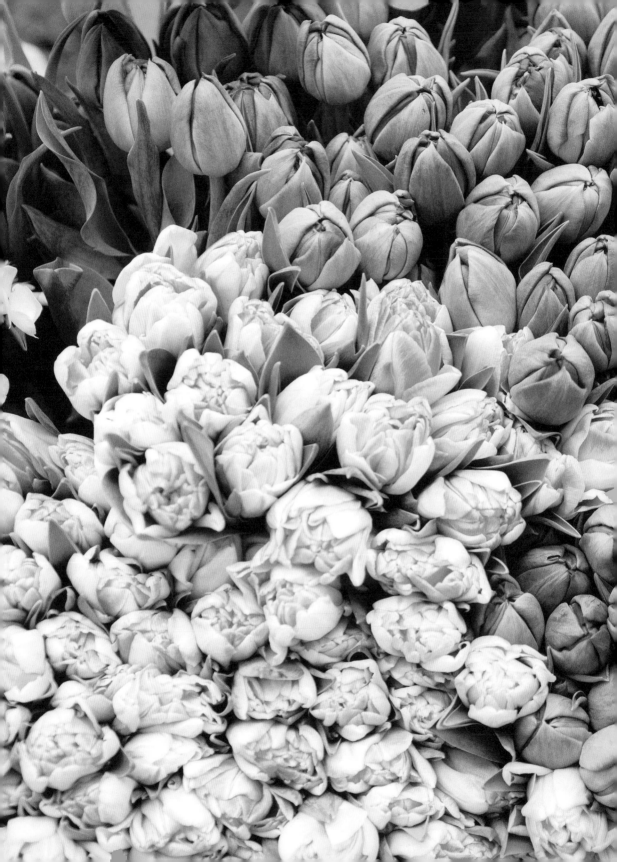

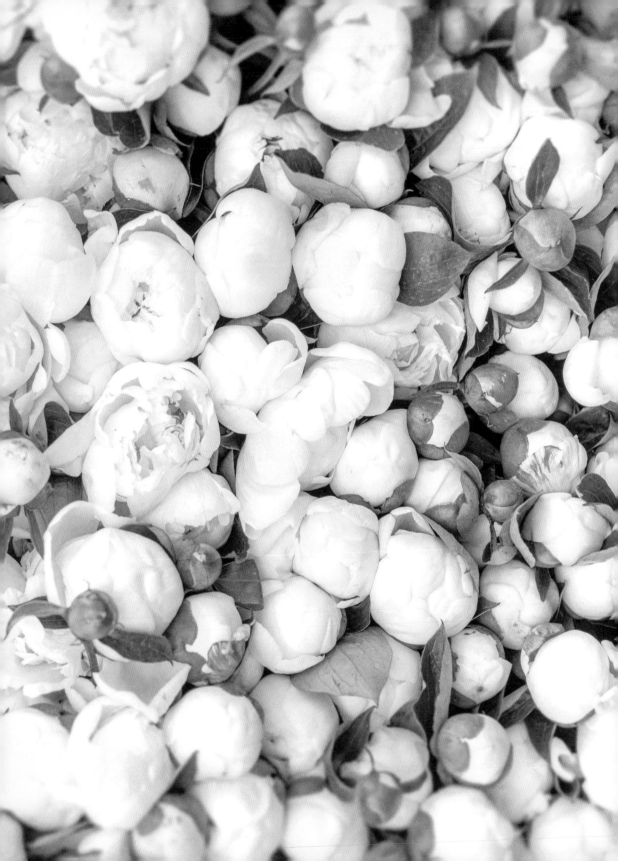

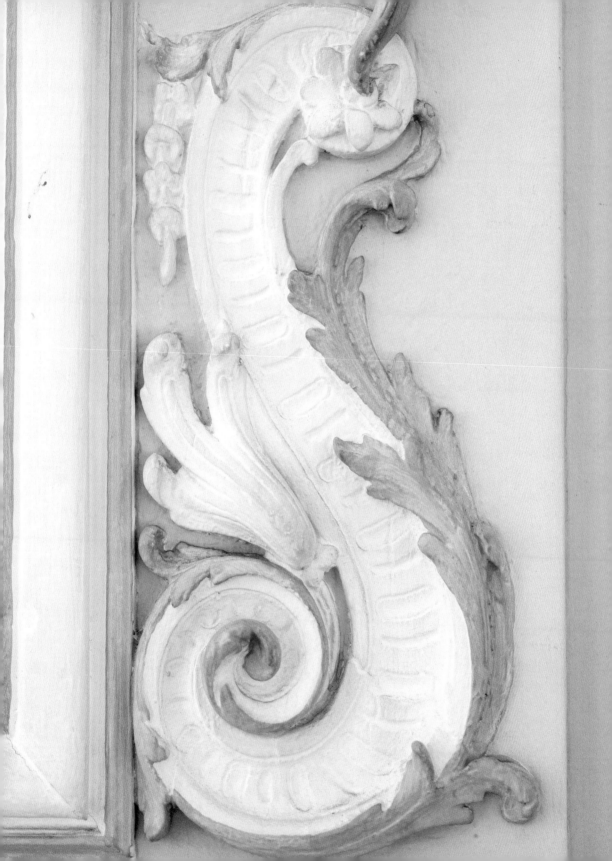

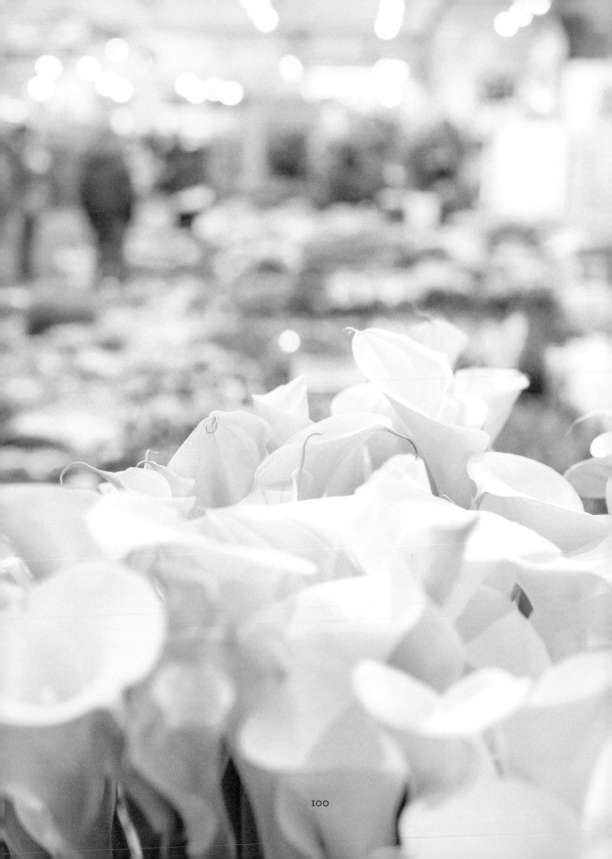

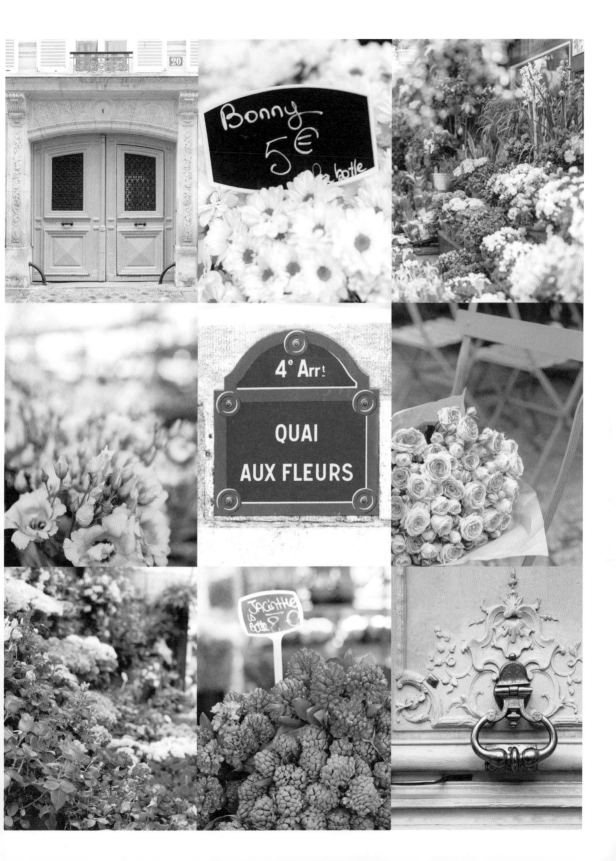

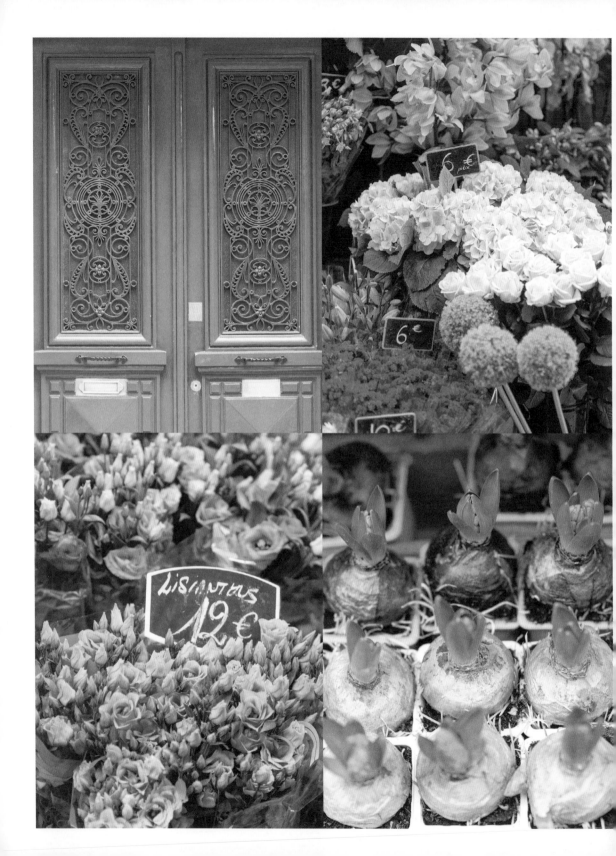

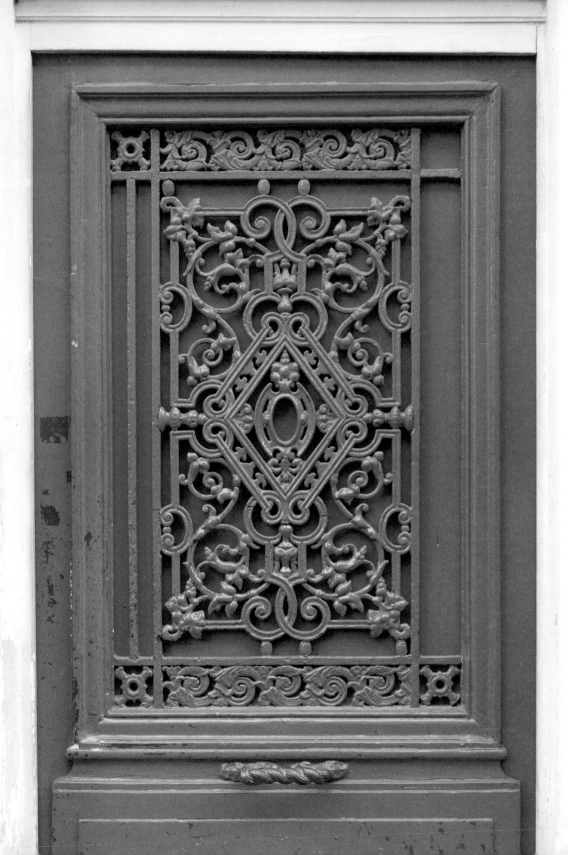

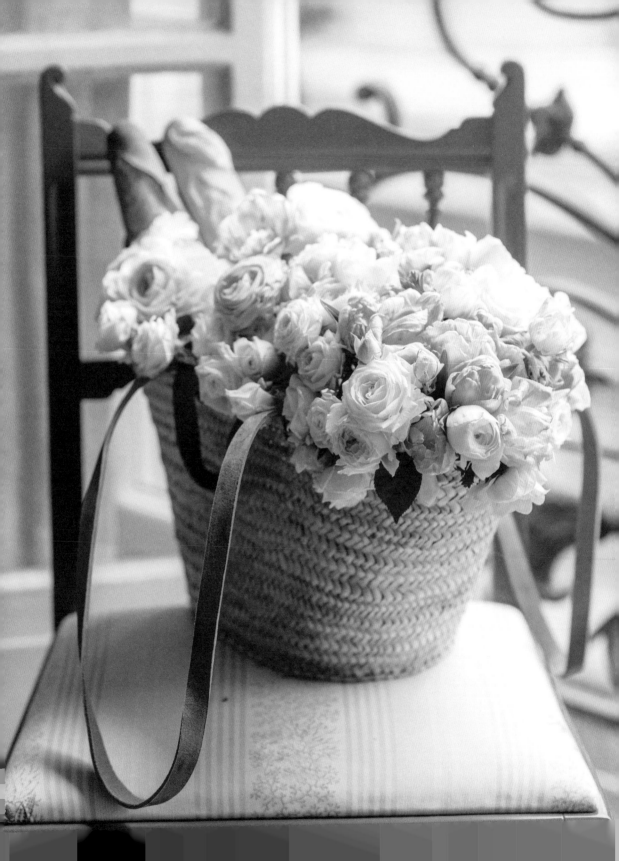

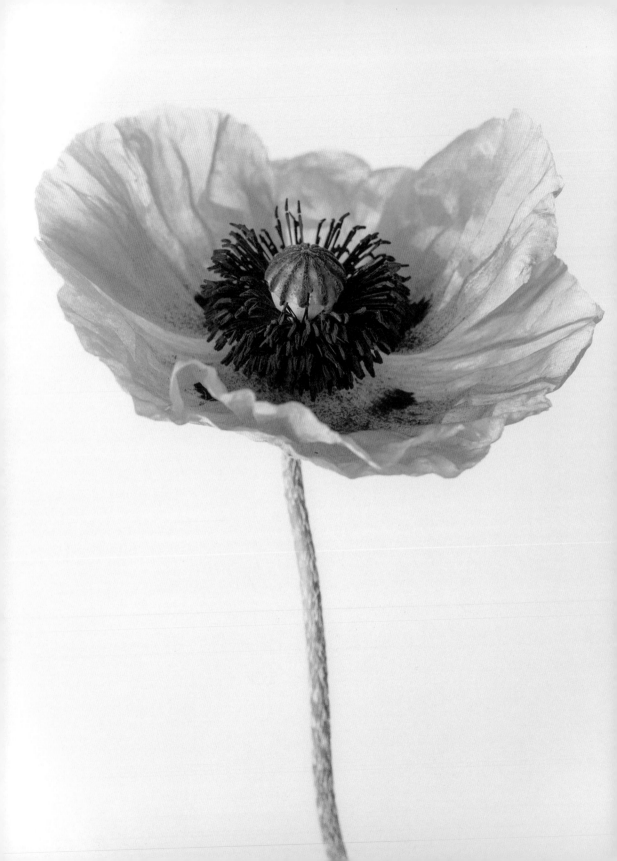

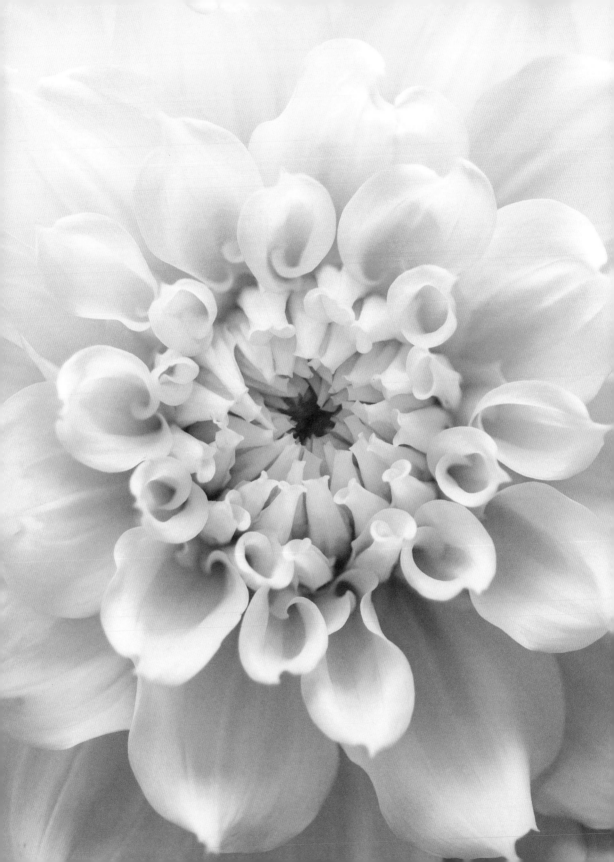

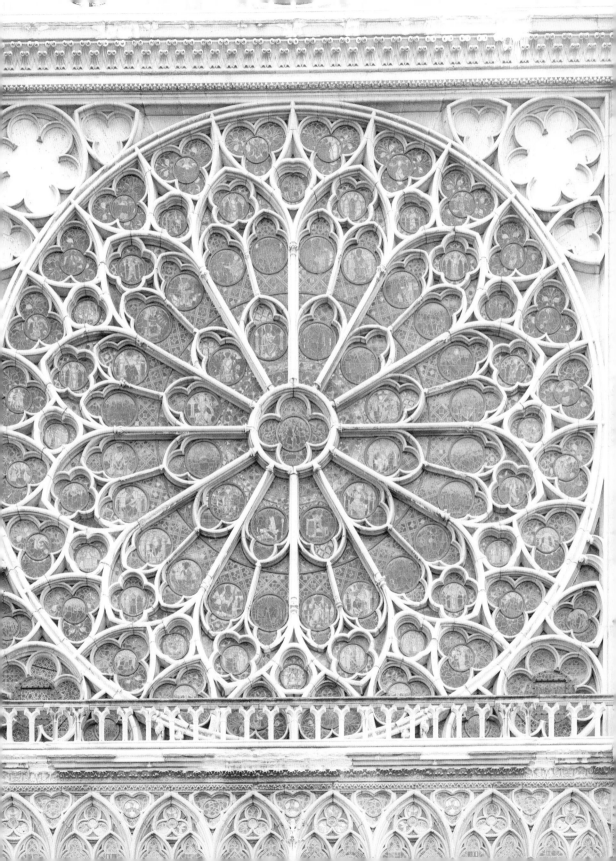

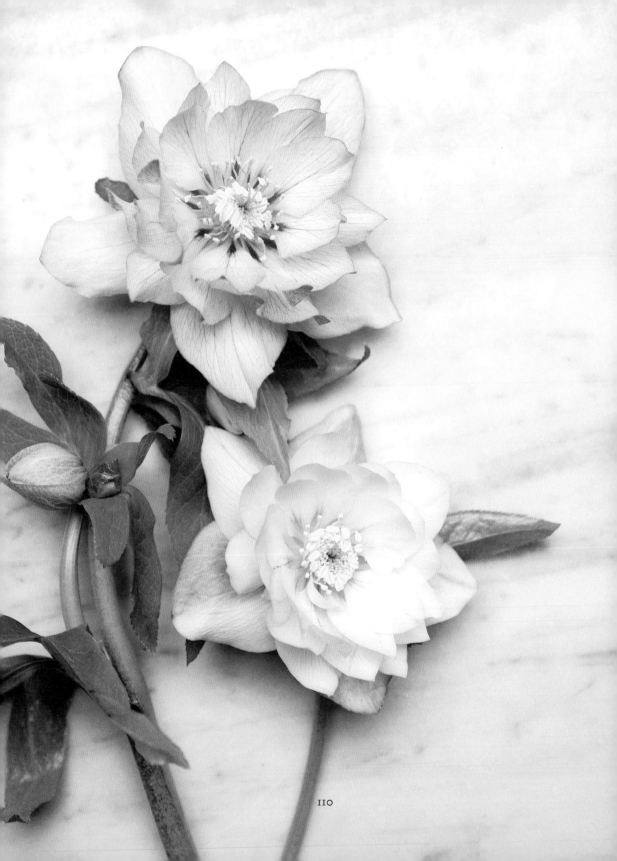

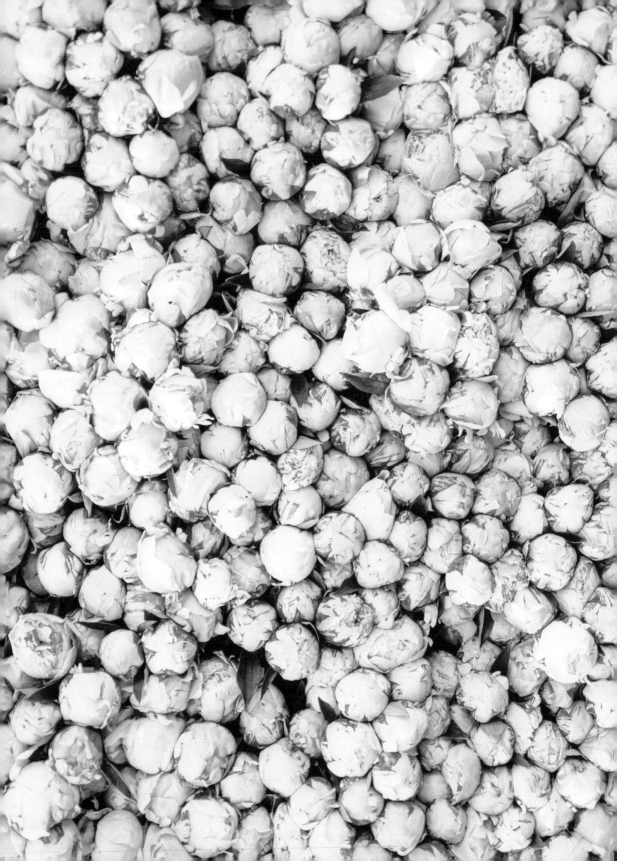

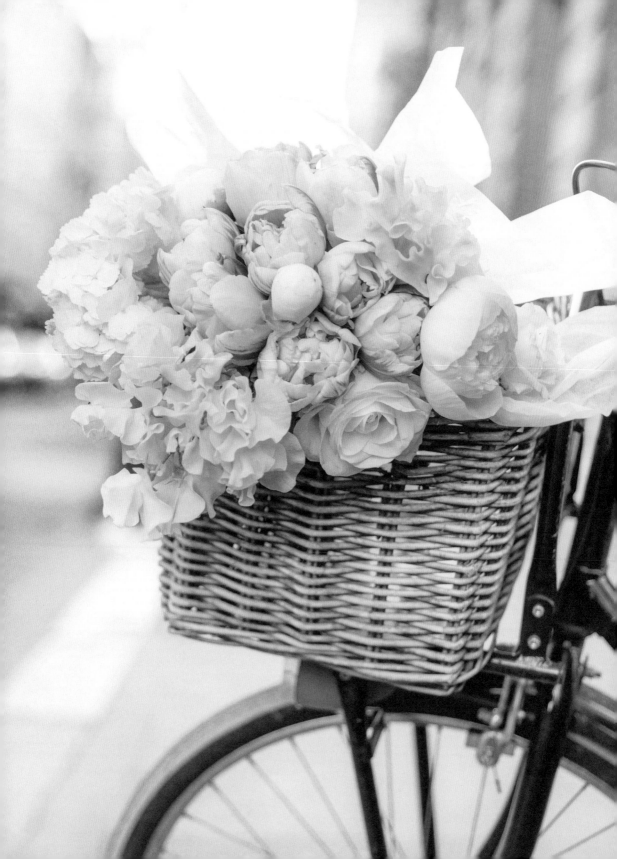

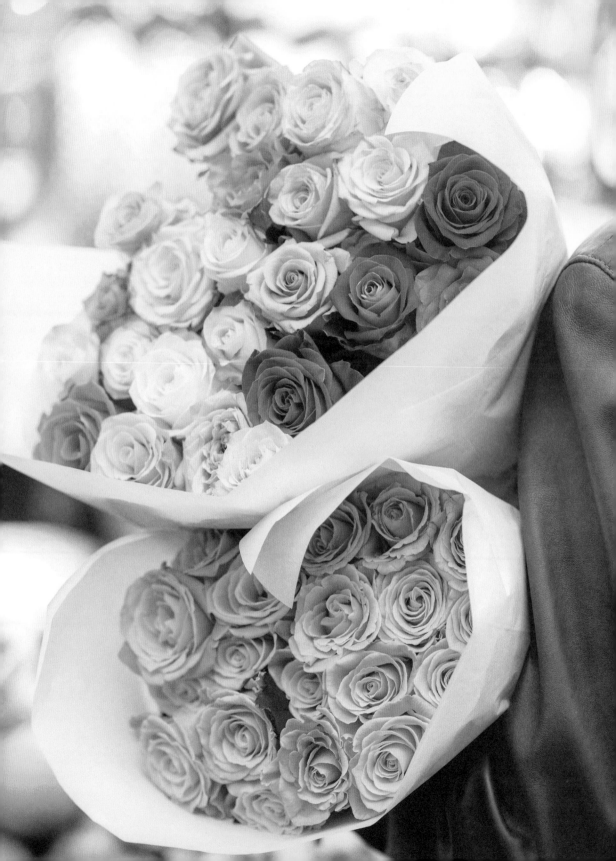

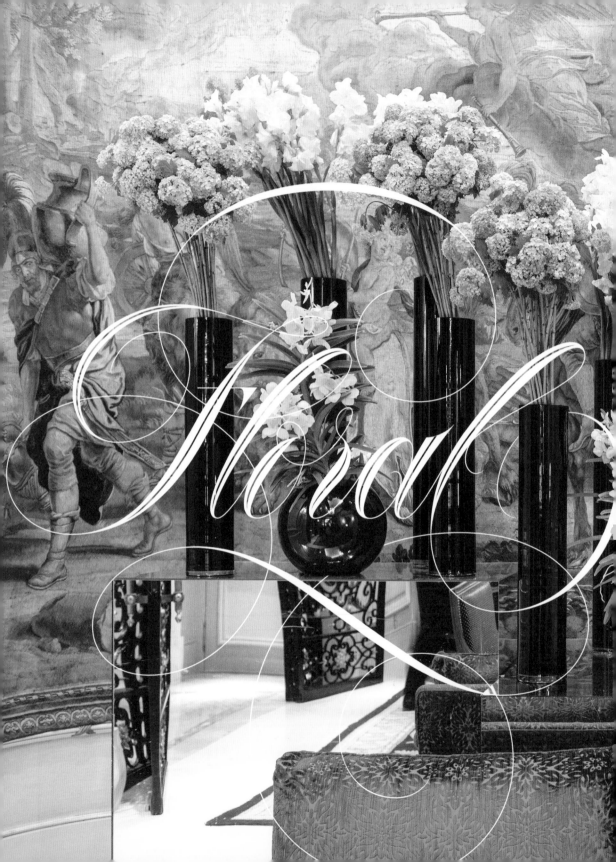

Floral

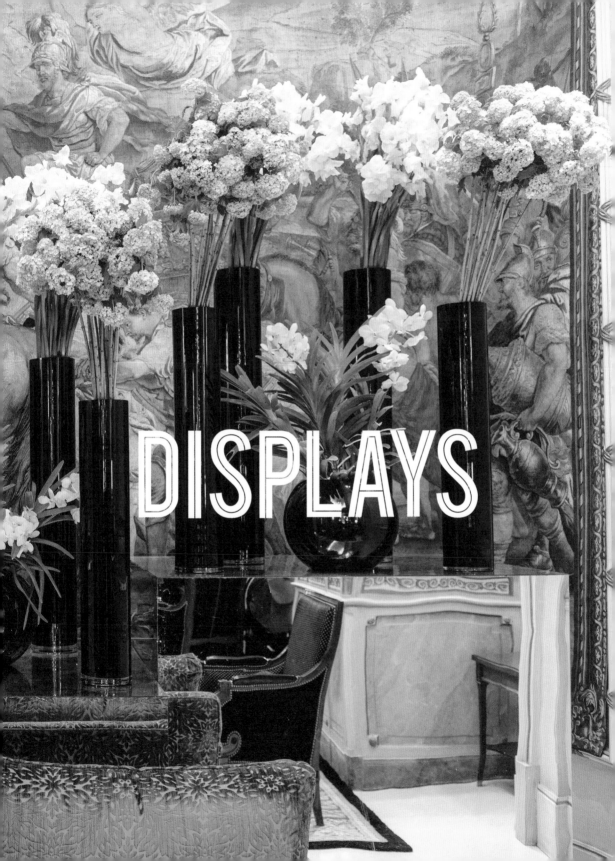

DISPLAYS

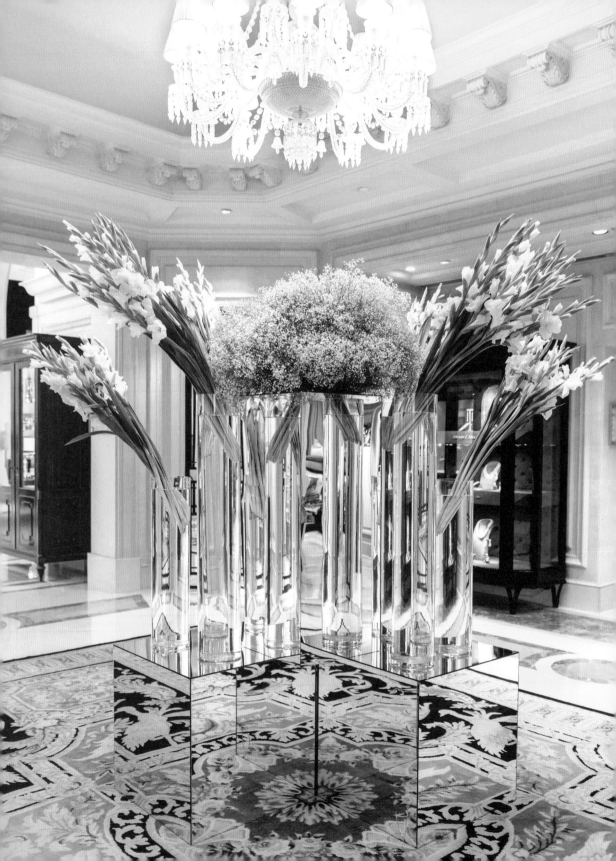

V isit Paris once and before long, almost inevitably, visions of your own *pied-à-terre* in the City of Love begin to seep into your imagination. Romance-filled fantasies of quintessential Haussman apartments in the 7th arrondissement with lofty tendril-carved ceilings, glimmering parquet floors, and sweeping views of the Eiffel tower or of tiny but stylishly chic lofts in Montmartre, decorated with eclectic finds from the local *brocantes*, occupy more idle moments than you might admit.

Perhaps musings of your dream Parisian home have been inspired long before ever visiting—an essential element in your perfectly imagined life of culture, style, literature, and fashion. Dwelling in Paris carries a *cachet* like nowhere else.

And, as Parisians demonstrate daily, flowers bring joy and grace to city life in limitless variation. For one—an ornately carved marble mantle swathed in roses, tulips, and ranunculus, reflecting the light of a crystal chandelier or for another— a simple but equally beautiful bunch of market daisies carefully displayed in a vintage jar. Formal arrangements of long-stemmed roses echoing the curved lines of an antique chest; a casual bundle of fresh market flowers at table while enjoying coffee and pastry; potted annuals perking up a miniature balcony above the jumbled roof-tops of Paris—the flowery scenes are infinite and played out daily.

Imagine a spring bouquet of white lilac and jasmine on a terrace in the foreground of a staggering view of the Champ de Mars and the Eiffel Tower. Or a bountiful armload of white orchids overfilling mirrored pedestal vases. Hot shades of gerbera daisies and amaryllis create a sharp juxtaposition of intense color against a modern neutral decor. In winter, a small but cozy flat might be enveloped in a cloud

of scented winter hyacinth and narcissus, bought at the twice-weekly street market. Showy and precious peonies are expensive indulgences but much cherished. All make their own statement of gracious living.

On the first of May each year, nearly every Parisian home will be filled with the marvelous scent of Lily of the Valley, to celebrate the Fête du Muguet. A symbol of good luck, the centuries-old tradition of giving a small bouquet or sprig of muguet des bois as a sign of love and affection on May Day remains tremendously popular, with touching and tender scenes played out all over the city: vendors set up tables devoted to pretty displays of muguet wrapped and in pots, helping customers pick just the right one for the intended recipient; a well-dressed local gentleman carefully chooses and purchases four small bouquets from a flower market on rue Cler and then presents them to each of the girls behind the counter at the next door boulangerie; and an elderly woman inspects and smells a number of bouquets until she is satisfied that her purchase is the most fragrant possible. Wandering through the markets, one observes that nearly all of the passersby, no matter their age or walk of life, are carrying (and sniffing) muguet in a sweet gesture of pure pleasure.

Beyond the courtyards and private residences, the art of floral expression outside the home is a Parisian specialty. Fresh installations, designs, and motifs are set out on the visual stage of the city in all seasons. Always there will be a flowering plant on a metal café table or a hanging basket outside a boutique. Window treatments, luxury hotel lobbies, and department store interiors showcase the simple, the traditional and the outrageous in extravagant floral design.

Top fashion designers have long been influenced by botanical forms and routinely craft entire collections of haute couture garments, jewelry, shoes, and handbags around them. Elegant tea shops and patisseries offer sugar-blossom confections and petal-infused teas, one made with roses from the gardens at Versailles.

At apartment buildings, businesses, and high-end hotels in all neighborhoods, window boxes burst with cheerful annuals, most often trailing geraniums. Lovingly tended, they brighten the streets throughout the grey days of winter through spring, summer and well into autumn. The most stunning are found at the Hôtel Plaza Athénée on Avenue Montaigne, where spectacular crimson blooms, matched in hue

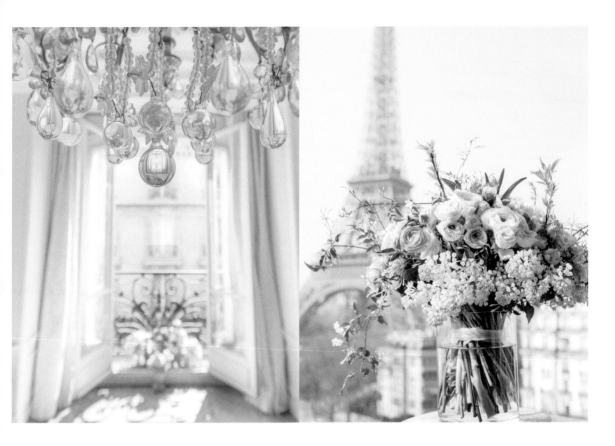

to the hotel's famous red awnings, avalanche over the curved balconies in a flounce of petals.

Exquisitely painted Napoleon III era interiors, such as those at the Hotel Shangri-La, depict delicate bouquets arching out of classic urns—roses, lilies, irises, and sweet peas amid swirly borders of gold. Ceiling details, furniture inlays, and door surrounds all echo the rounded, curving shapes of nature.

Truly the ultimate in breathtaking, cutting-edge floral performance is to be found at the Hotel Four Seasons George V, where designer Jeff Leatham and his team create eye-popping tableaux of hydrangea, peonies, gladioli, orchids and calla lilies in an unforgettable setting of opulence and classic Parisian style. Stop in to marvel at the flowers and treat yourself to the luxurious afternoon tea in La Galerie.

Dreams do come true and details matter, so while envisioning your charmed life with the zinc roofs and darling chimney pots of Paris outside your window, be sure to include luscious, fragrant bouquets of your favorite flowers.

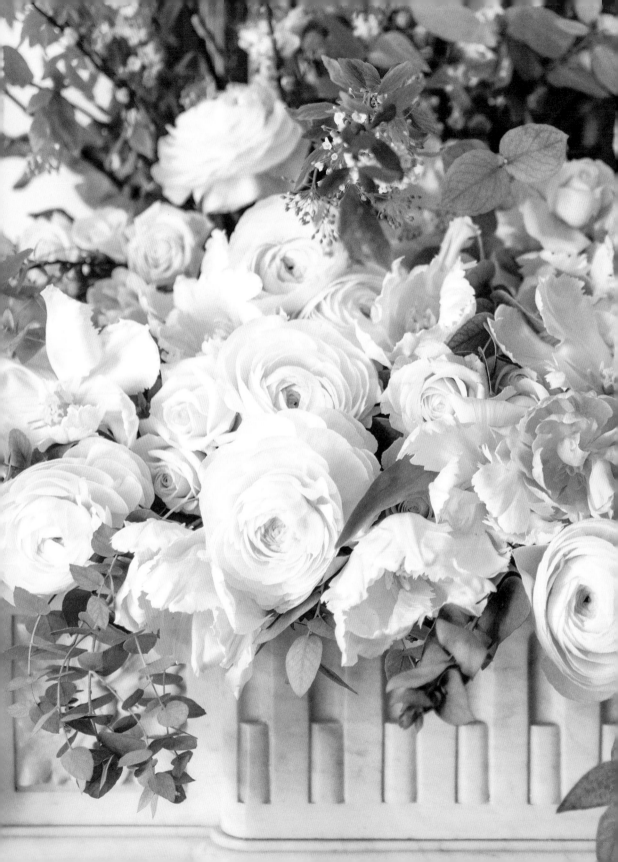

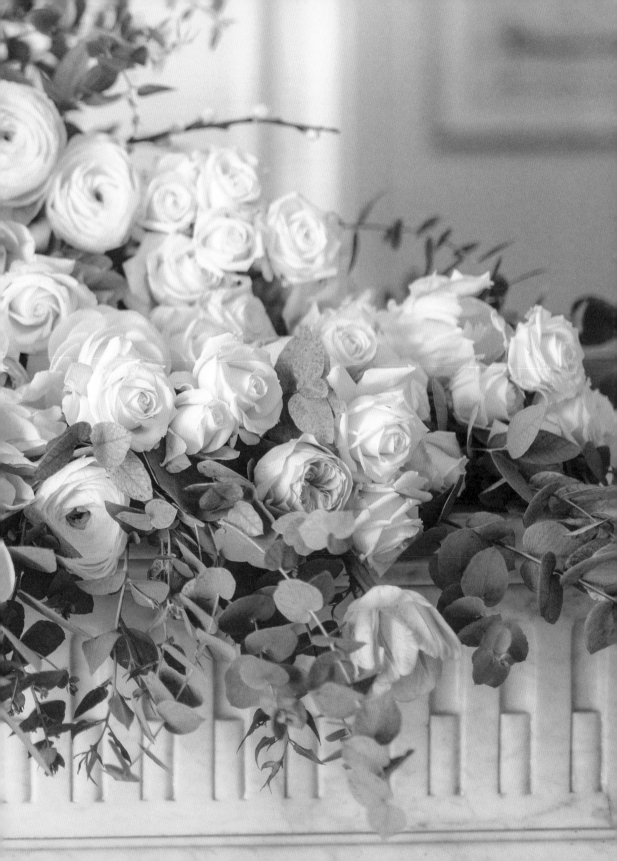

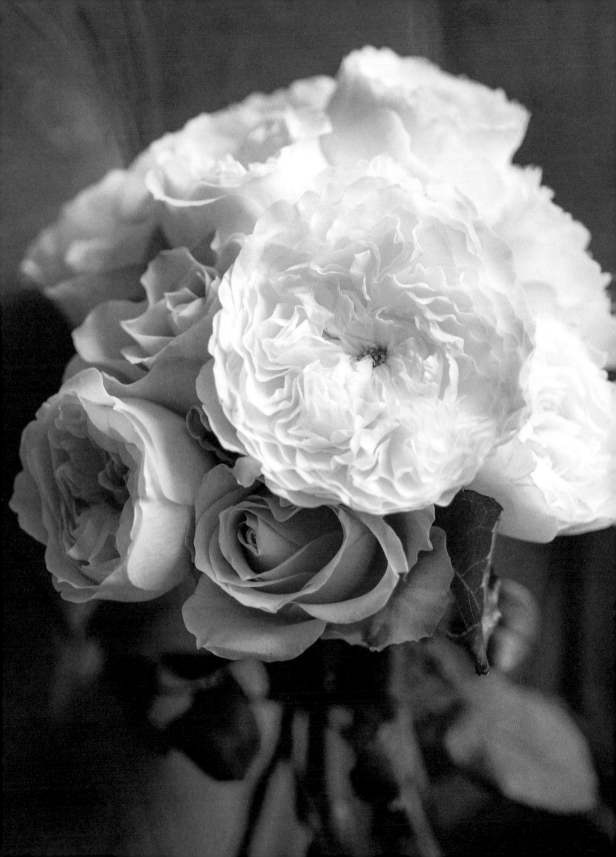

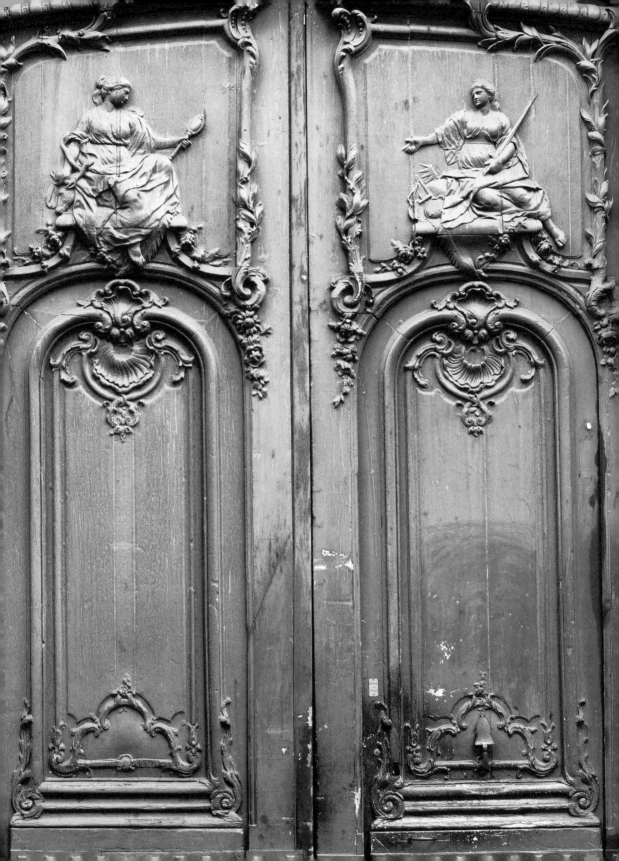

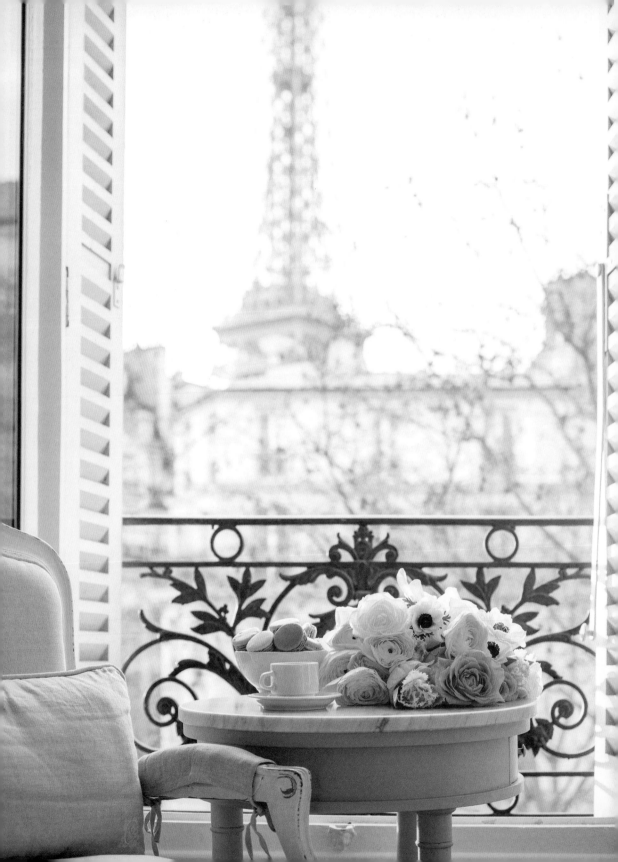

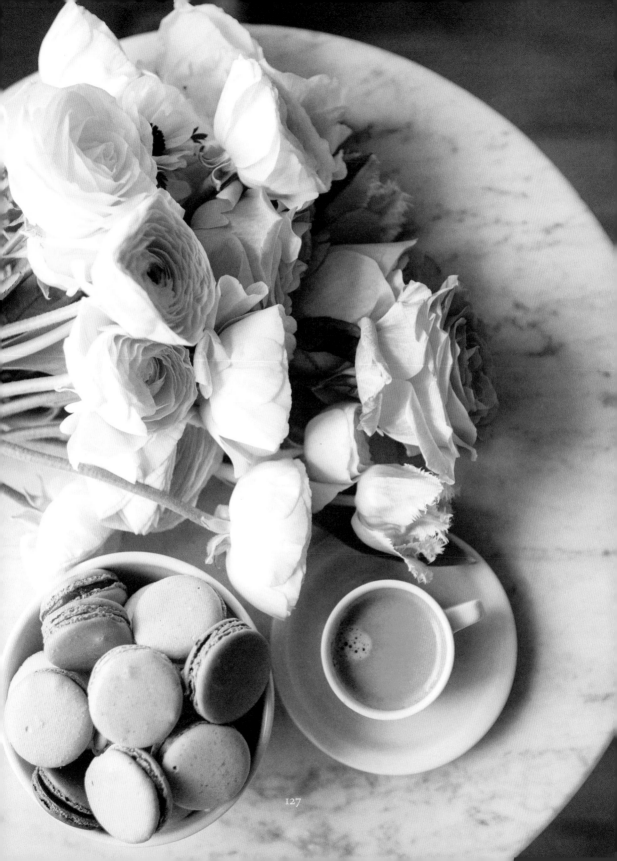

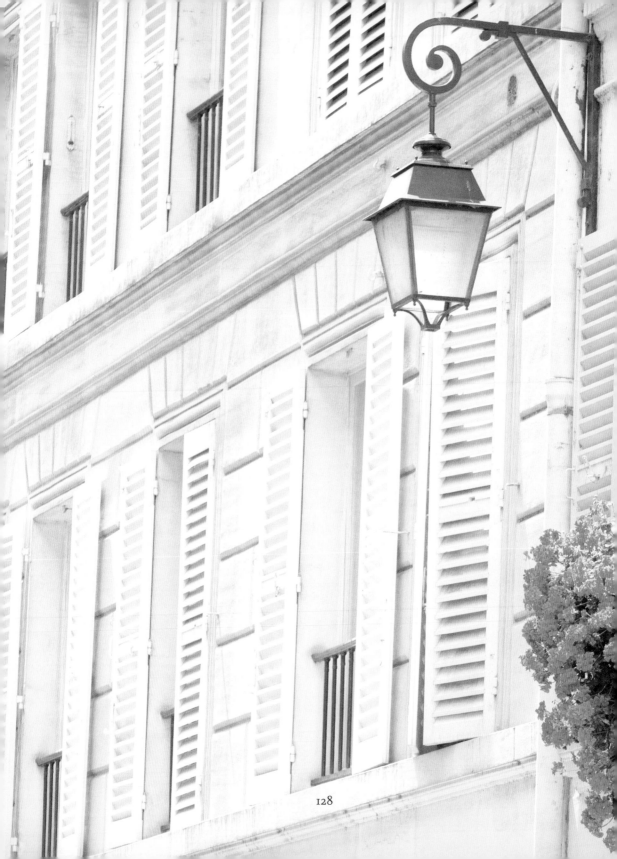

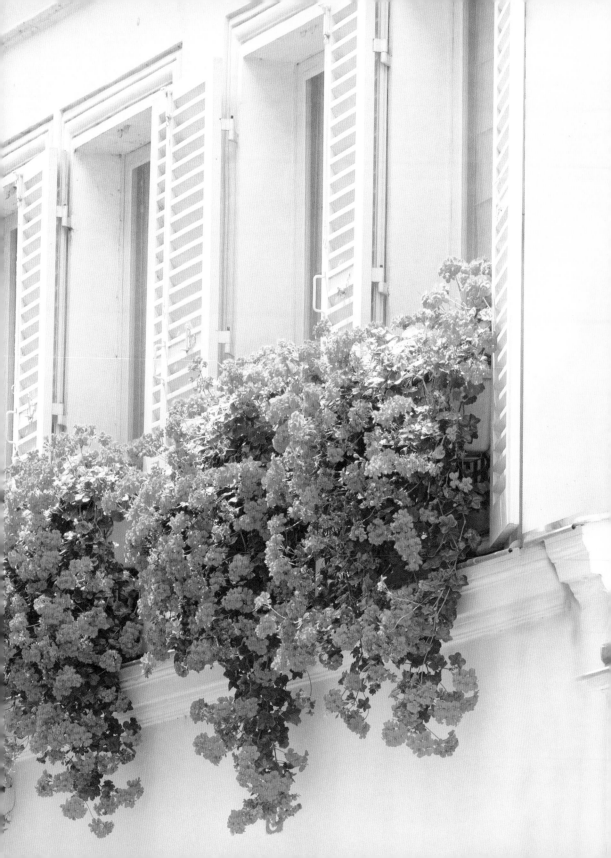

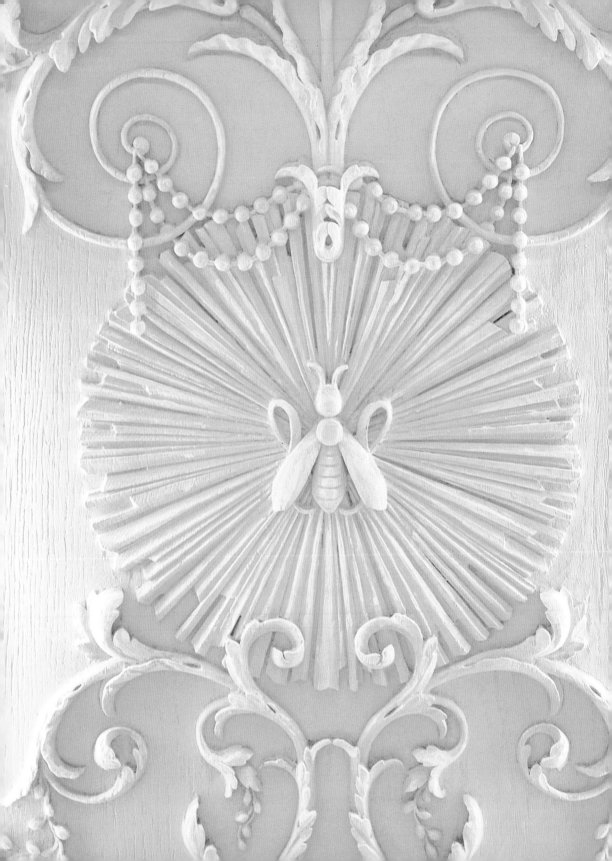

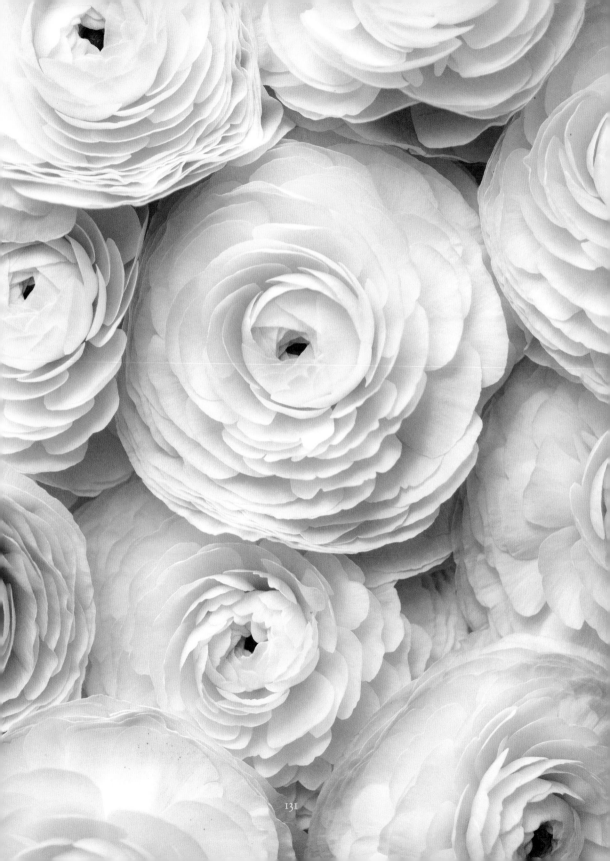

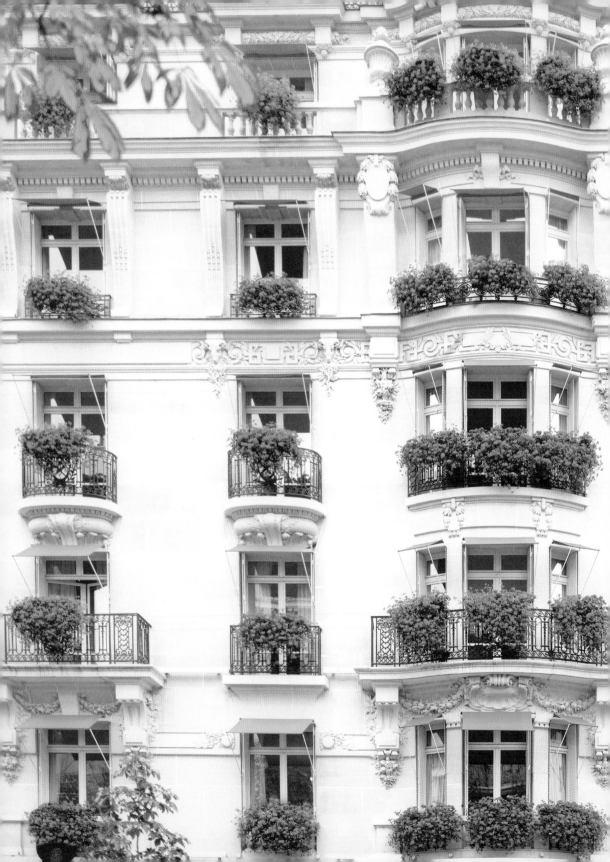

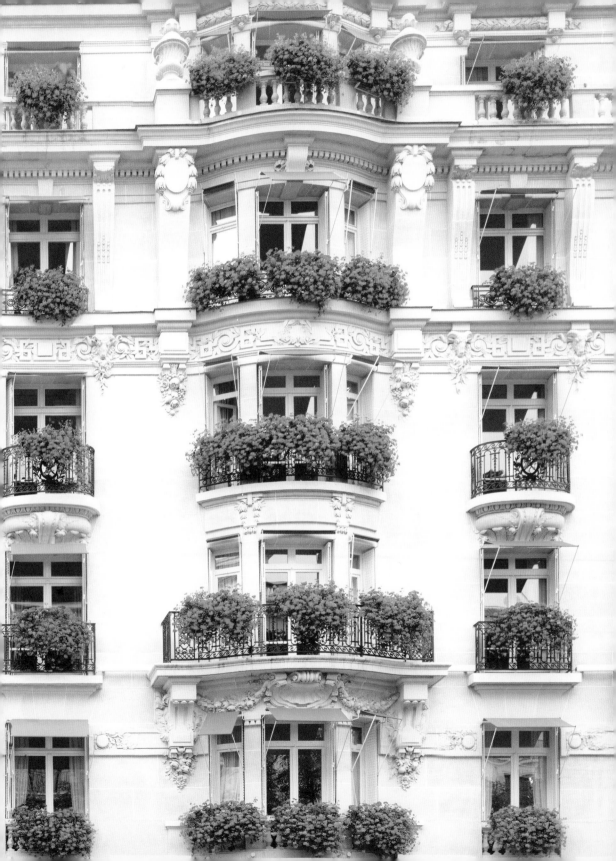

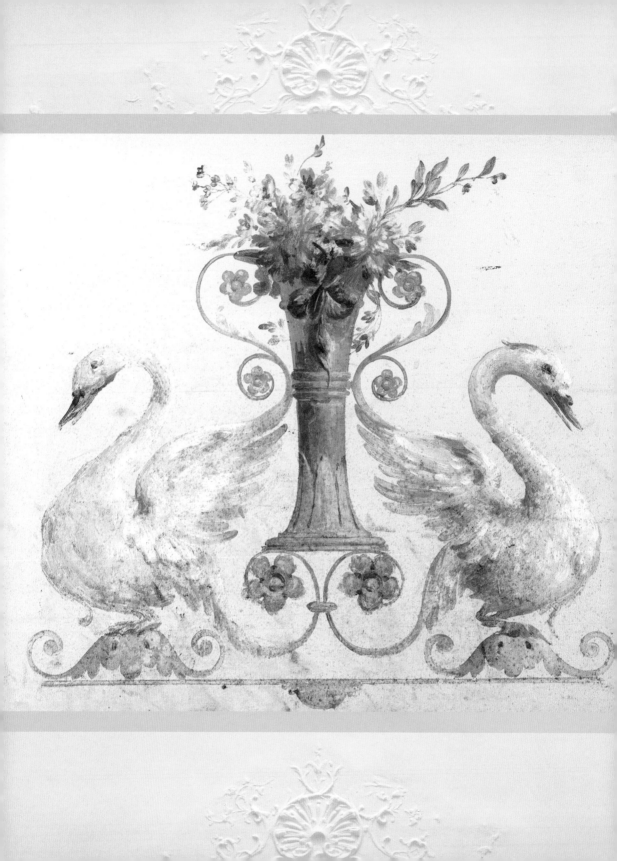

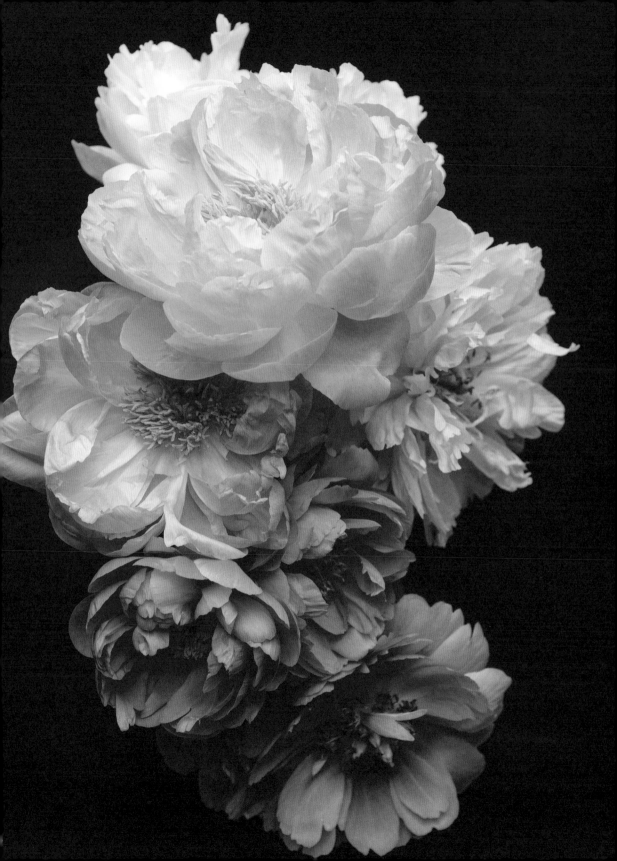

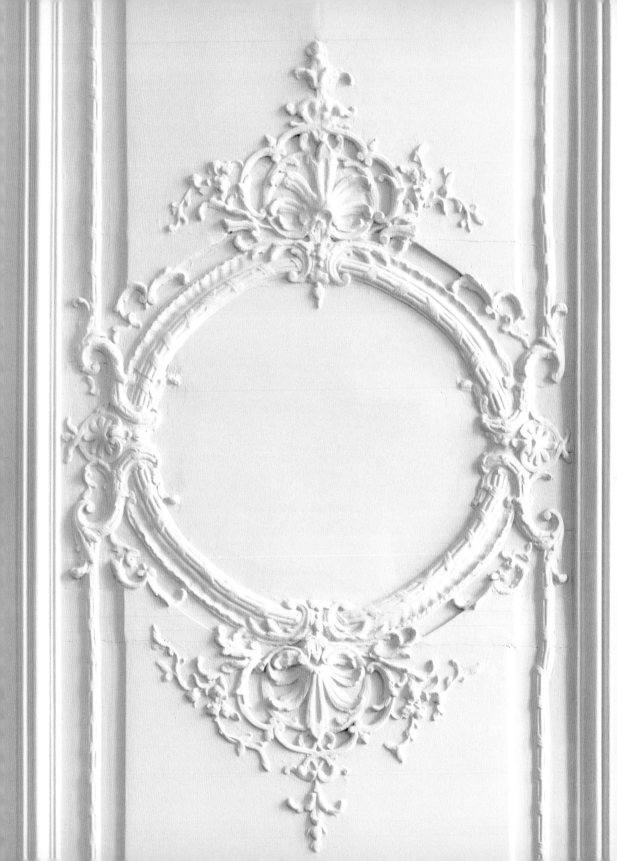

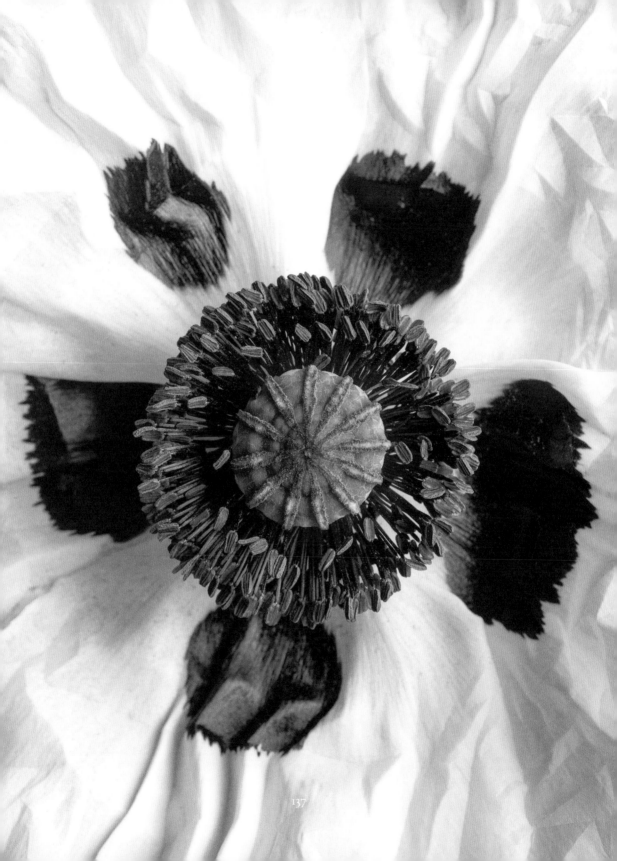

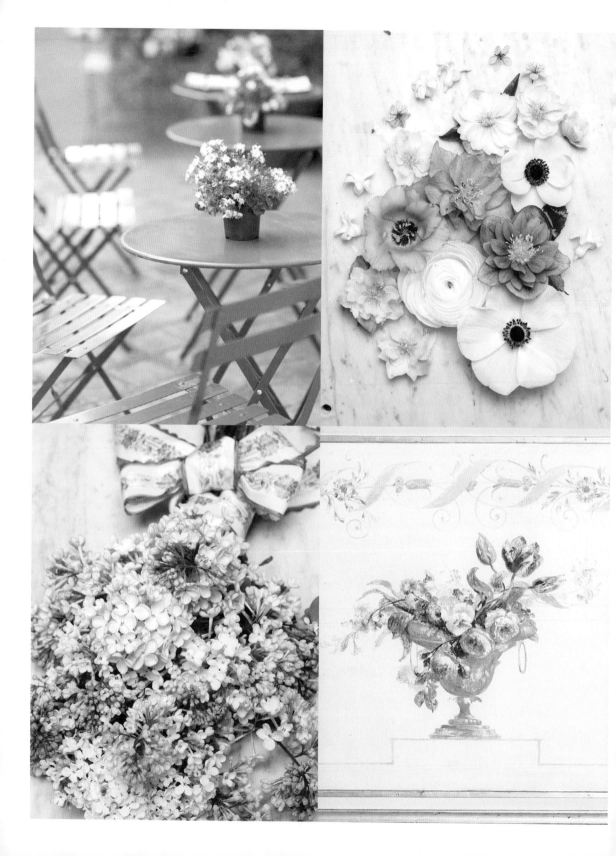

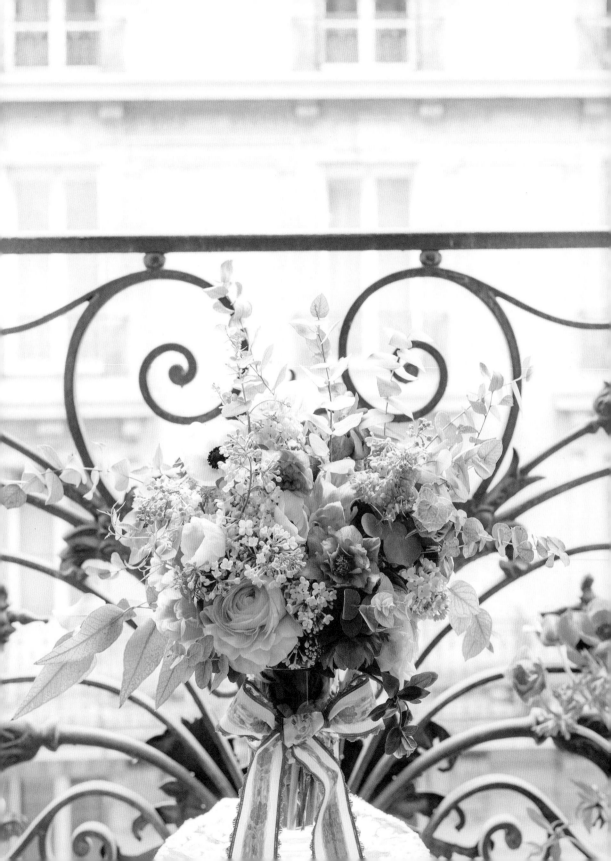

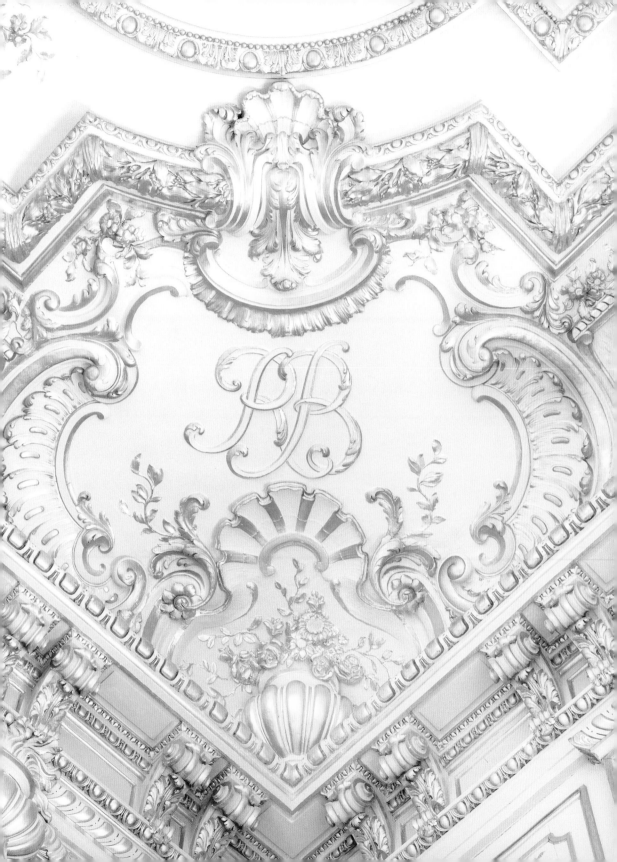

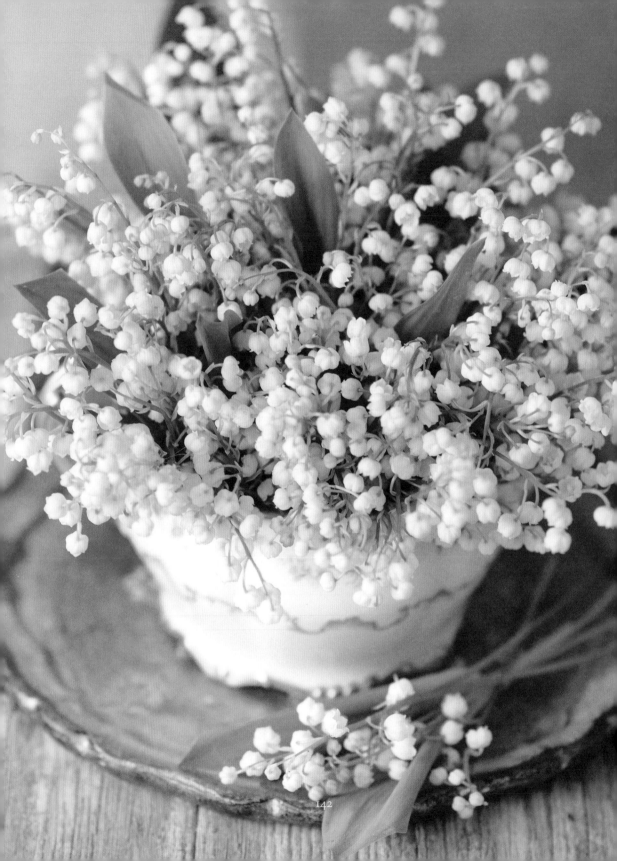

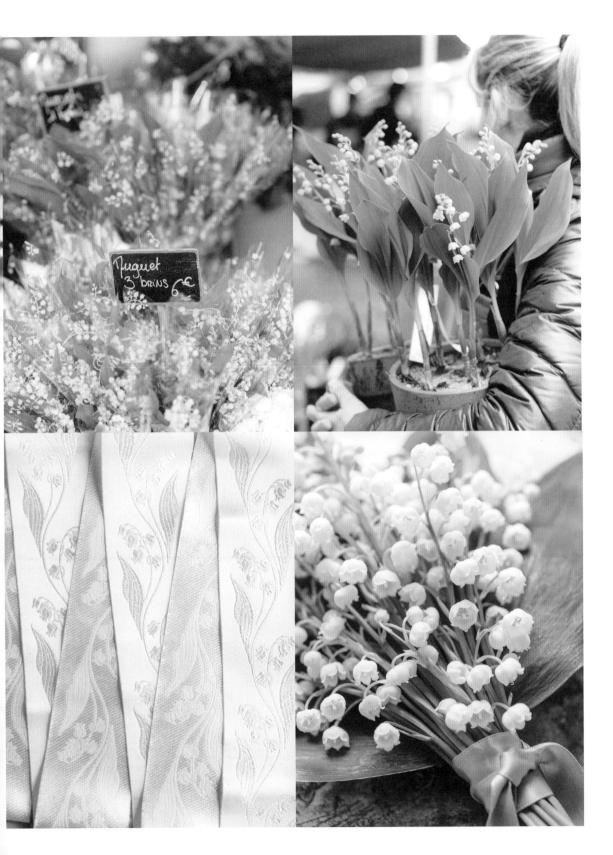

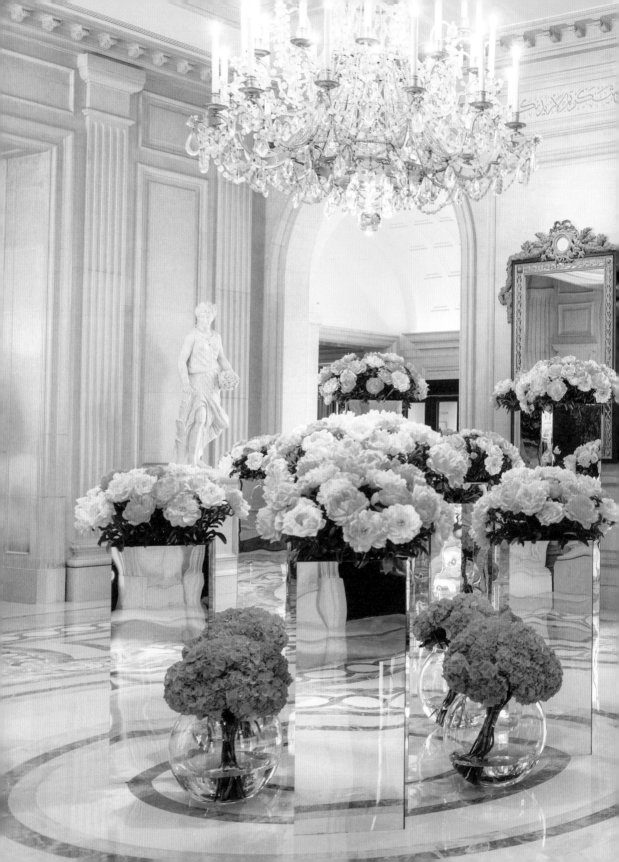

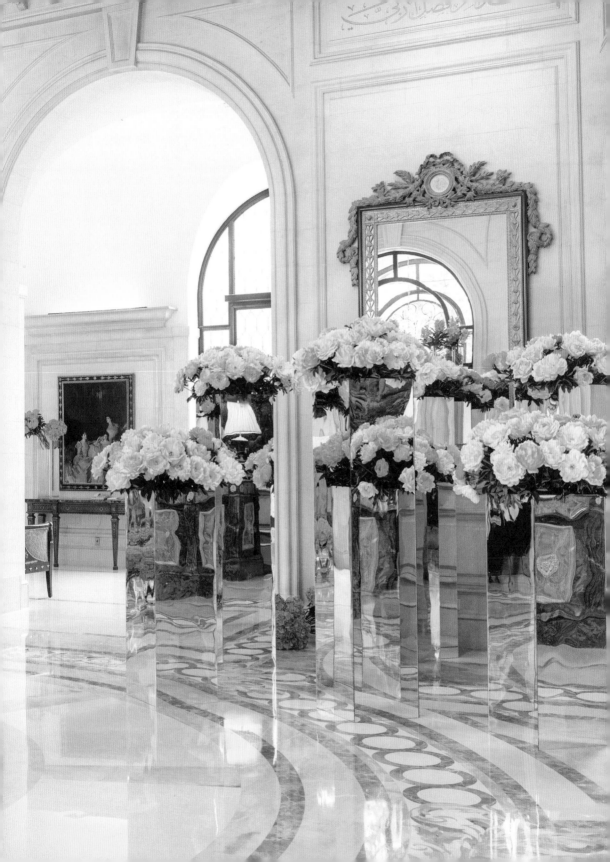

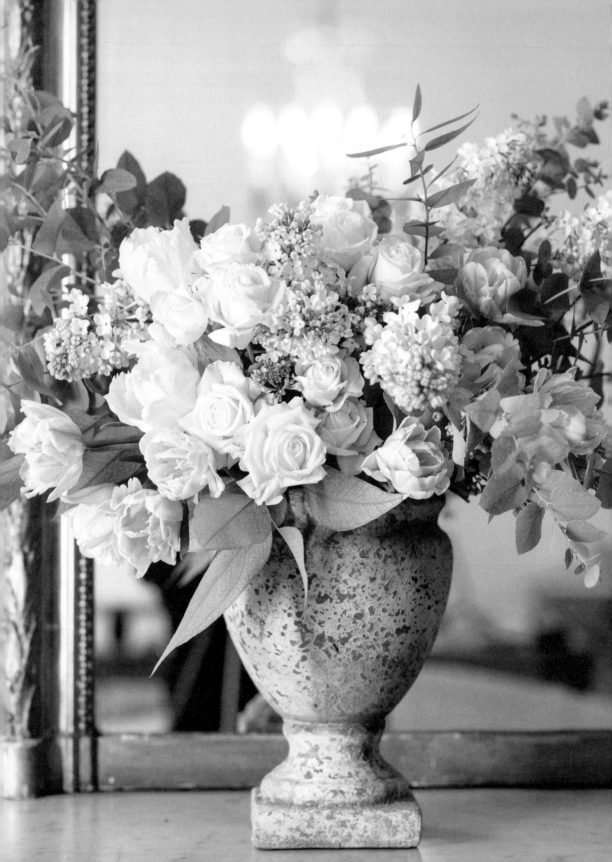

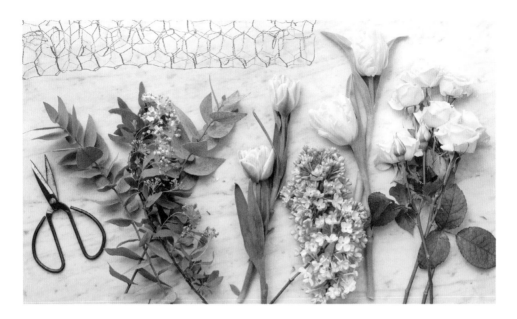

With these simple steps and readily available supplies, you can create your own romantic and fragrant arrangement to bring Parisian flair to your home.

You will need:

1. A 12" square of chicken wire cut from a roll using tin snips
2. Thick gardening gloves to wear while shaping the chicken wire
3. A suitable decorative container, such as an urn or shapely vase, that will hold water
4. Floral clippers strong enough to cut stems
5. Flowers, foliage, and fillers:

a. Choose up to three different types of cut foliage in colors and textures that will contrast and complement your main flowers. Foliage will form the structure and basis of your arrangement so don't choose limp or flimsy varieties.

b. Choose three or four featured flowers in complementary colors. Here we've used white single tulips, pale pink Parrot tulips, multi-hued lilacs, and white spray roses, all of which are available at most any flower market or grocery store in season. You could also use ranunculus, peonies, narcissus, stock, sweet peas, mums, dahlias, gerbera daisies, garden roses, snapdragons, or any other pretty cut flowers. Consider shape, texture, color, and fragrance.

Steps:

1. Prepare all flowers and foliage by stripping off excess leaves that will sit below water level in the container. Remove any thorns from roses. Cut the stems at an angle and put them in fresh water while you prepare the vase with the chicken wire and arrange the foliage.

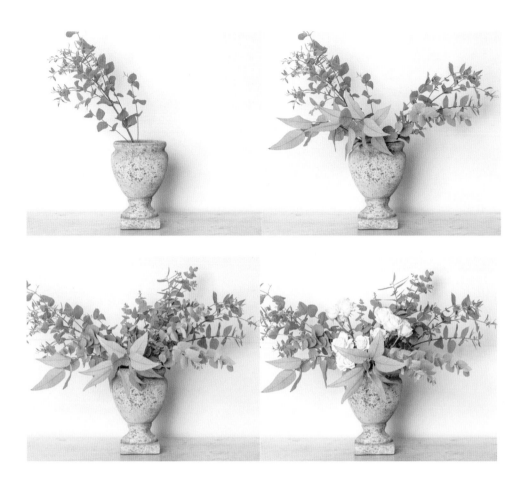

2. Wearing gloves, crush the chicken wire into a loose ball, taking care not to poke yourself on the sharp edges.

3. Place the chicken wire into the container and fill with water.

4. Select nice looking stems of each different foliage plant. Cut to the appropriate length for the size and shape of arrangement you envision. Hold them up before you place them in the container to ensure they are not too long. Trim as needed.

5. Place the first bunch in the container on the left side as shown, securing the stems in the chicken wire. Select further stems and arrange on the right. Leave some negative space off center for interest. Add further foliage in front to create a pleasing shape and cover the edge of the container.

6. Continue to add foliage until you have a good foundation and range of colors and textures. Ensure all the stems are stable and securely held in the chicken wire.

7. Choose your first featured flowers, preferably round flowers (ours are off-white spray roses), and trim to a

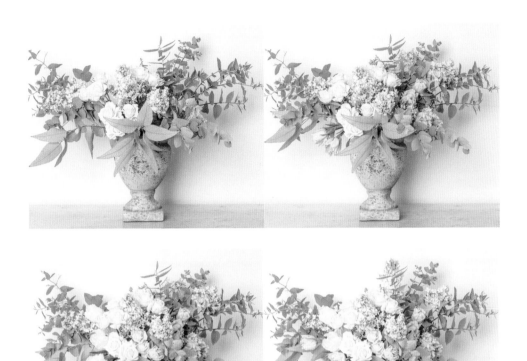

length that will allow them to nestle in amongst the foliage in the front. Place in a prominent spot and cluster together in threes or fives (uneven numbers create interest). Add several bunches as shown. Ensure they are secured in position and will not droop or fall out.

8. Begin to add the secondary flowers (we've used lilacs) to give color and more texture. Place them on the sides and behind the roses.

9. Add in the third flower (ours are tulips) and cut and drape as needed to have some hang and fall gracefully over the edge of the container.

10. Fill in any gaps with flowers, trimming the stems as needed.

11. Look at your arrangement from all angles and handle any gaps or holes.

12. Display in a location where it will bring you joy and be admired and appreciated. Be sure to check water level several times a day and change it daily. Floral preservative will also help to prolong the life and freshness of the flowers.

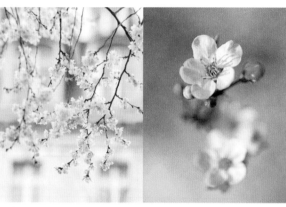

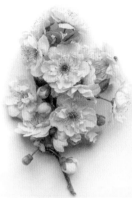

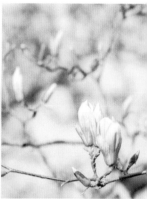

Winter-flowering cherry
(*Prunus subhirtella* 'Autumnalis')

Cherry plum
(*Prunus cerasifera* 'Thundercloud')

Blireana plum
(*Prunus x blireana*)

Magnolia
(*Magnolia*)

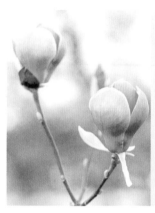

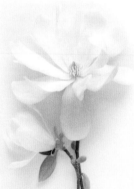

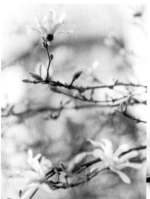

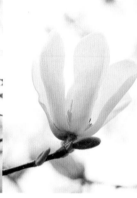

Saucer magnolia or tulip tree
(*Magnolia x soulangeana*)

White star magnolia
(*Magnolia stellata*)

Pink star magnolia
(*Magnolia stellata* 'Rosea')

Yellow magnolia
(*Magnolia x butterflies*)

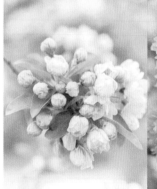

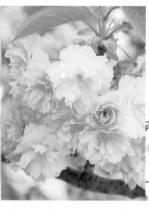

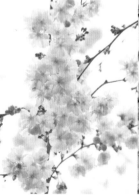

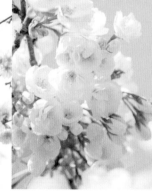

Chinese flowering crabapple
(*Malus spectabilis*)

Kwanzan cherry (*Prunus serrulata*
'Kwanzan')—sometimes called
Kanzan cherry

Accolade cherry
(*Prunus* 'Accolade')

Mount Fuji cherry
(*Prunus* 'Shirotae')

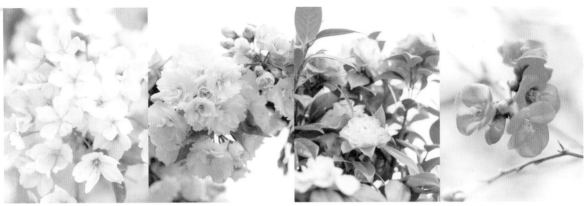

White cherry
(*Prunus yedoensis*)

Double white Japanese cherry
(*Prunus serrulata* var. alba)

Japanese camellia
(*Camellia japonica*)

Flowering quince
(*Chaenomeles*)

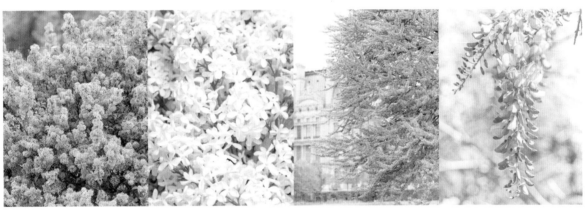

Lilac
(*Syringa vulgaris*)

White lilac
(*Syringa vulgaris*)

Judas tree
(*Cercis siliquastrum*)

Wisteria
(*Wisteria sinensis*)

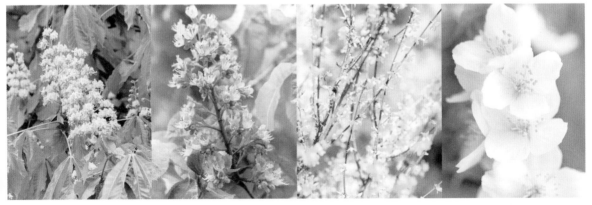

European horse chestnut
(*Aesculus hippocastanum*)

Red horse chestnut
(*Aesculus x carnea*)

Forsythia
(*Forsythia x intermedia*)

Mock Orange
(*Philadelphus*)

Here I share with you some of my favorite locations to see flowering trees and other plants in central Paris, all located within the 1st through 8th arrondissements. They will get you started on your own blossom hunt. A listing of more parks and gardens further afield follows.

Where: Jardin des Plantes
When: Something will always be blooming from late January on through May, including a variety of cherry trees, magnolias, crabapples, and lilacs. Two enormous trees are the scene-stealers here: a magnificent white Mount Fuji cherry blooms in late March/early April with trailing branches that cover the ground, and a majestic pink Kwanzan cherry (early to mid April) is alone a worthwhile reason to visit the Jardin.

Where: Jardin Tino-Rossi,
2 Quai Saint-Bernard, 75005
When: Early to mid-March for Plums
Early to mid-April for Kwanzan cherries

Where: Jardin du Palais-Royal
When: Early to mid March for magnolias, daffodils

Where: Jardin des Tuileries
When: Mid-April for the purple-flowered spears of the Judas tree, framing the Louvre in the distance

Where: Square Jean XXIII and the Left Bank side of Notre Dame Cathedral
When: Mid-to late March for magnolia blossoms in the garden facing the apse
Early to mid-April for a charming grove of Kwanzan cherry blossoms that create a pink canopy, white cherry blossoms, and lilacs.

Where: Rue Chanoinesse
When: Mid-to late April to see the wisteria draped facade of the Vieux Paris restaurant

Where: In front of Shakespeare and Company and Le Petit Châtelet restaurant (between rue de la Bûcherie and Quai de Montebello)
When: Early to mid-April for a sprinkling of Kwanzan cherry trees. While you're admiring them, have coffee at the Shakespeare and Company cafe and then wander into the famous bookstore next door.

Where: In front of Odette on 77 Rue Galande
When: Early April for the tall Bradford Pears near the patisserie

Where: Square René-Viviani
When: Early to mid-March for plums and magnolias. Also reputedly the oldest tree in Paris.

Where: Place Dauphine, Île de la Cité
When: Mid-to late April for blooming chestnut trees that fill the square

Where: Marché aux Fleurs Île de la Cité
When: February and throughout the spring the market features seasonal blooming plants and trees including camellias, azaleas, and rhododendrons

Where: Jardin Marie Trintignant, at the corner of Rue du Fauconnier and Quai des Célestins
When: Early to mid-April. There is a small green space with a good collection of Kwanzan cherry trees, they'll be in bloom at the same time as those at Notre Dame and Jardin Des Plantes.

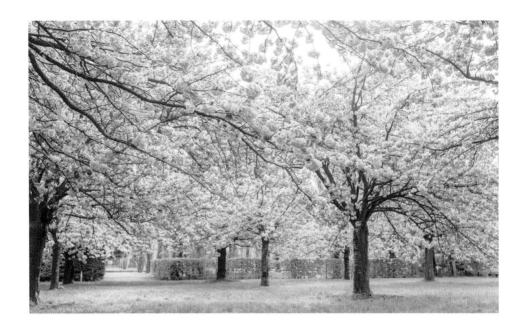

Where: Hôtel de Ville, on the river side
When: Early to mid-March, two impressive magnolia trees, flanking the equestrian statue of Étienne Marcel, burst into bloom creating a stunning tableau against the architecture of the Hôtel de Ville

Where: Parc Monceau
When: Beginning in late January/early February when the early cherry trees bloom and continuing through the spring with magnolias, plums, and other flowering trees

Where: Champ de Mars
When: Early March to see plums blooming
Mid-to late March for magnolias and camellias
Early to mid-April for cherries

Where: Avenue Émile Deschanel, near the Champ de Mars
When: Late April the mature chestnut trees that line both sides of the road are heavy with deep pink spires of blossoms

ULTIMATE CHERRY BLOSSOM VIEWING

Where: Parc de Sceaux (above), six miles south of Paris
When: In early to mid-April, a magical orchard of dozens of Kwanzan cherry trees creates a pink haven. Highly recommended to see the blossoms and the beautiful château and park. (Note: the peak bloom has been as late as the last week of April. Keep an eye on the Kwanzan cherry trees at Notre Dame or Jardin des Plantes as a gauge of when to travel to the Parc.)

OTHER RECOMMENDED PARKS AND GARDENS IN THE GREATER PARIS AREA:

Bois de Vincennes
Parc des Buttes-Chaumont
Parc de Belleville
Promenade Plantée
Bois de Boulogne
Parc de Bagatelle

A wealth of wonderful parks and gardens, floral boutiques, flower shops, and markets exists in Paris. This is not a comprehensive guide but, instead, my personal favorites and recommendations—the places I go to enjoy and to buy flowers when I'm in Paris.

PARKS AND GARDENS

Palais-Royal (Pages 4, 16, 24, 35)
8, rue de Montpensier, Paris 75001

Magnolias and daffodils in spring, roses in summer, dahlias and anemones in autumn, and graphic, sculptural trees in winter, all set against architecture of symmetrical perfection, accented by the black-and-white striped *Colonnes de Buren*. This is my absolute favorite location in Paris.

Jardin des Tuileries (Pages 9, 10–11, 26–27, 39, 47)
113, rue de Rivoli, Paris 75001

A close second on my list, the Jardin des Tuileries offers views of the Louvre, the Musée d'Orsay, and Place de la Concorde and is the home of the Roue de Paris. Glorious in April, when tulips and locust trees are flowering, and in late spring, when the beds are spiked with lupine, it is most dramatic in autumn when the *allées* of plane trees turn golden and the paths are deep with crunchy leaves.

Jardin du Luxembourg (Pages 2–3, 12, 15, 16, 17, 24, 35)
6th arrondissement, Paris 75006

Centrally located yet a world removed from the constant whir of life in Paris, the expanse of Jardin du Luxembourg, home of the French Senate, casts a unique spell. Stroll awhile, then lean back in the famous Senat chairs and be amazed at the calm that seeps into your soul. Breathe deeply. Exhale. You'll consider never leaving. The gorgeous dawn light is like nowhere else in the city.

Cathédrale Notre-Dame de Paris and square Jean XXIII (Pages 1, 16, 18–19, 24, 40, 109)
6, parvis Notre-Dame, place Jean-Paul II, Paris 75004

Square Jean XXIII, named for Pope John, offers a peaceful interlude with its colorful flowerbeds. A sweet white star magnolia graces the edge of the park near the apse. In April, the river side of the cathedral hosts one of the nicest small groves of blooming Kwanzan cherry trees in the city.

Parc Monceau (Pages 36–37)
35, boulevard de Courcelles, Paris 75008

Timeless and classic, Parc Monceau can be visited any time of year to enjoy the graceful structures and botanical plantings, and it displays very early spring blooming cherry trees on the south side entrance.

Musée Rodin (Pages 22–23, 24, 31, 75)
79, rue de Varenne, Paris 75007

One of the most beautiful museums in Paris is also home to one of the most beautiful rose gardens. Visit in mid- to late May and be dazzled by the extravagant blooming display. Enjoying the combination of incredible artworks by a supreme master housed in a stunning building and grounds of aesthetic perfection is truly one of the best days to be had in Paris—or anywhere.

Champ de Mars (Pages 6, 16)
2, allée Adrienne Lecouvrer, Paris 75007

With the Eiffel Tower as the backdrop, you can't go wrong with Champ de Mars as a destination. It is also home to a respectable botanical collection of trees, shrubs, and flowering plants. Anytime from mid-February on, you'll find flowering plums, magnolias, and cherries. They are not clustered together, so expect a bit of a scavenger hunt, but the rewards are there to be discovered.

FLORAL BOUTIQUES

Moulié Fleurs (Pages 57, 70)
8, place du Palais Bourbon, Paris 75007

A legendary shop on the elegant place du Palais Bourbon, Moulié carries on a tradition of floral excellence and classic design with exquisite displays.

Omotesando by David Martinot (Pages 60–61, 67, 121, 131)
44, avenue de la Bourdonnais, Paris 75007

Omotesando is one of my personal favorites for cut flowers and bouquets when staying in the 7th arrondissement. I love David Martinot's shop front with its garlands and twinkle lights, and he is charming and welcoming.

Eric Chauvin Un Jour de Fleurs (Pages 9, 63–65, 79)
22, rue Jean Nicot, Paris 75007

This is simply one of the very best shops in Paris. Eric Chauvin provides brilliant floral designs for top designers and events in the city, and the shop is a gorgeous venue and wonderful place to pop into for your own bouquet.

Vertumne (Pages 52–53)
12, rue de la Sourdière, Paris 75001

Vertumne is one of the prettiest floral boutiques with always beautiful displays. Located down a quiet street off rue Saint-Honoré, I can always count on superb-quality and wonderfully creative arrangements.

Roses Costes Dani Roses (Pages 54, 57, 85)
239, rue Saint-Honoré, Paris 75001

Probably the most-photographed floral windows in Paris. Specializing in roses, the sumptuous vases and urns display the most gorgeous varieties. It's a tiny shop, but stop in and be dazzled by the mirrored walls and ceiling reflecting the floral extravagance. You'll also find the loveliest people— Fabrice will create a bouquet whose beauty will bring tears to your eyes.

Flower.fr (Pages 80–81)
La Boutique des Saints-Pères
14, rue des Saints-Pères, Paris 750076

Here you'll experience the most arresting street displays of intricately designed window shelves and a seasonal arrangement in front of the adjacent teal doors.

Au Nom de la Rose (Pages 67, 82)
Various locations

Also specializing in roses, Au Nom de la Rose shops are so, so Parisian with their petal-strewn floors and bright combinations. The shops also provide great gifts, such as candied rose petals and rose-infused tea.

MARKET FLOWERS

Marché Président Wilson
Avenue du Président Wilson, Paris 75116
Open Wednesdays and Saturdays

This is my choice for the most beautiful of all the street markets. The vendors take extra care to create artistic and tempting displays. Walking from one end to the other is a crowded, fragrant, visually stimulating stroll of pure sensory pleasure.

Marché Bastille
Boulevard Richard Lenoir, Paris 75011
Open Thursdays and Sundays

Big, boisterous and full of everything you can imagine, if you only ever frequent one market in Paris, this would be a fabulous choice.

Marché Maubert
Place Maubert, Paris 75005
Open Tuesdays, Thursdays, and Saturdays

A smaller but more easily navigable market, the flower vendors here are friendly and passionate. I've always found it a wonderful source of peonies in May.

Cler Fleurs
46, rue Cler, Paris 75007

Cler Fleurs is an institution on rue Cler, frequented by elegant Parisian matrons and trendy couples. And the street offers plenty of cafés and shops for most anything you need.

Anaïs
52, rue Montorgueil, Paris 75002

The most enjoyable feature of this shop is its colorful displays that pour out onto rue Montorgueil. All types of flowers are available in all seasons.

INDEX OF PHOTOGRAPHS

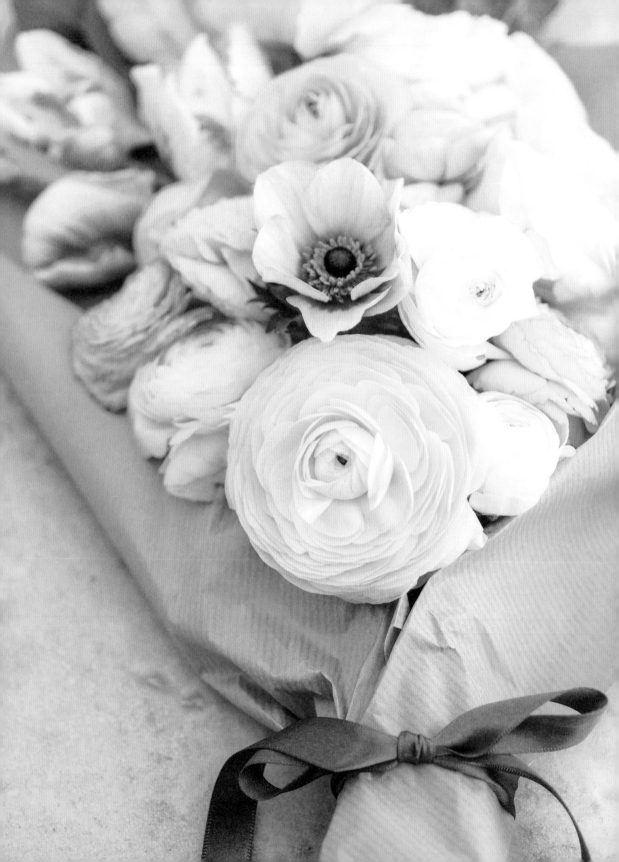

DEDICATION

To my mother, who took me on my first trip to Paris, and to my father, who made it all happen.

ACKNOWLEDGMENTS

Writing and photographing a book celebrating the floral heritage of Paris has been a dream come true and a great privilege. Every photograph has its own story with its own cast of characters, and I am immensely grateful to these individuals and organizations for their exceptionally generous contributions:

My wonderful agent Kate Woodrow for her belief in this project and for her positive, insightful direction.

My stellar editors at Abrams, Camaren Subhiyah and Karrie Witkin, and talented art directors Darilyn Carnes and Hana Nakamura, for their enthusiasm and expertise in bringing this book to life and for making the journey a complete delight.

The brilliant Nim Ben-Reuven for creating the marvelous calligraphy that waltzes across the pages.

The directors and staff of the Paris museums and galleries where I was granted private access to photograph the gorgeous floral design details, including The Louvre, Musée Rodin, Musée Carnavalet, Hôtel de Soubise, and Chateau de Versailles.

The executives and staff of the Four Seasons Hotel George V for their superlative service, friendliness and professionalism, and to floral designer extraordinaire Jeff Leatham and his team, whose magnificent creations in the hotel add a dramatic flair to the final chapter.

The executives and staff of the Hotel Shangri-La for such a gracious welcome and for considerate access to photograph the splendid beauty of the hotel interiors.

The creative and stylish *artisan fleuristes* of Paris, a constant source of inspiration, who all went out of their way to support this project: David Martinot, of Omotesando; the staff at Costes Roses Dani Roses; Eric Chauvin and staff; Henri Moulié and Julien Moulié of Moulié Fleurs; Clarisse Béraud and her staff at Vertumne; and the floral design team at Flower.fr.

Laetitia Mayor, of floral design studio Florésie, for the laughter-filled, pre-dawn floral adventure to Marché Rungis and for creating the beautiful step-by-step arrangement in the appendix.

The executives and staff of Café Pouchkine for allowing me to photograph the exquisite Russian carved panel in the café.

Photographer Carla Coulson for her joy, inspiration and encouragement, and for that pivotal coffee date at Boot Café.

Madelyn Willems and the staff of Paris Perfect Rentals for ensuring I was ensconced in an elegant, Eiffel Tower view apartment—an inspiring haven in which to write this book.

My cherished siblings and fellow world travelers Leslie, Robert, David and Tom, who have been unfailingly supportive—you are always with me every step of the way.

My globetrotting parents, both adventurers and seekers, who instilled in us an incurable wanderlust and a passionate appreciation for adventure, culture, and art.

My husband, creative foil, business partner, traveling buddy, logistics genius, and resident diplomat, David Phillips, who orchestrated most of the location shoots and managed our business interests so that I could devote myself to creating this book. No words will ever be adequate.

Finally, my heartfelt gratitude to my beloved Paris and the remarkable Parisians—the dreamers, artists, craftsmen, designers—past, present, and future. When in Paris, I am my more stylish, artistic, and creative self. The most eloquent tribute I can make to this glorious city is the images I humbly present here.

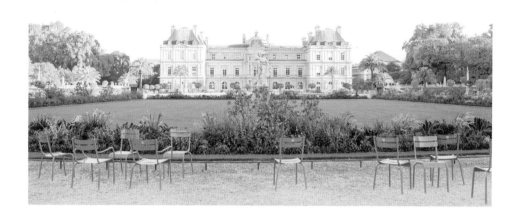

Editor: Camaren Subhiyah
Designer: Darilyn Lowe Carnes
Production Manager: True Sims

Library of Congress Control Number: 2016946247

ISBN: 978-1-4197-2406-0

Printed and bound in China
10 9 8 7 6 5 4 3 2

ABRAMS The Art of Books
115 West 18th Street, New York, NY 10011
abramsbooks.com